DRAWING GALLERY

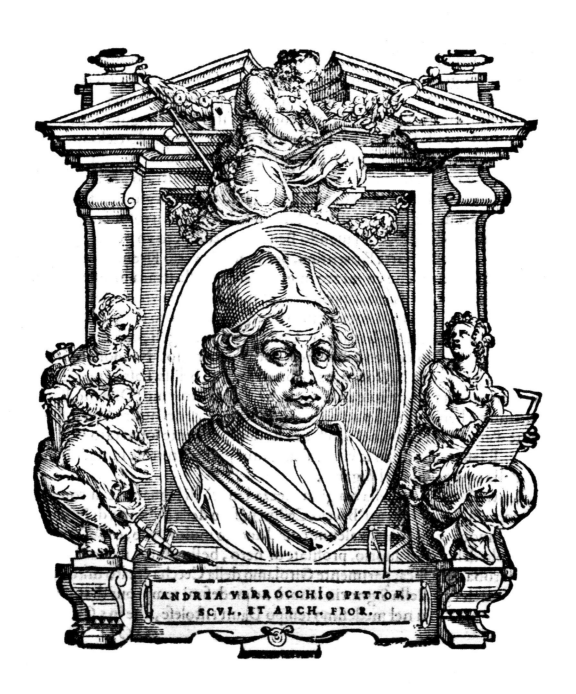

ANDREA VERROCCHIO PITTOR,
SCVL. ET ARCH. FIOR.

DRAWING GALLERY

Verrocchio, Lorenzo di Credi, Francesco di Simone Ferrucci

Gigetta Dalli Regoli

Entries by Laura Angelucci and Roberta Serra

CONTINENTS

Cover
LORENZO DI CREDI, *Study of drapery for the figure of Saint Bartholomew* (pl. 29).

Frontispiece
Portrait of Andrea del Verrocchio, from GIORGIO VASARI, *Le Vite de' più eccellenti Pittori, Scultori ed Architettori*, Giunti, Firenze, 1568, I, p. 480.

For the Musée du Louvre:

Editorial Coordinator
Violaine Bouvet-Lanselle

Iconography
Carole Nicolas
Christine André
Annie Madec

© Musée du Louvre, Paris, 2003
© 5 Continents Editions srl, Milan, 2003

http://www.louvre.fr
info@5continentseditions.com

ISBN Musée du Louvre: 2-901785-51-4
ISBN 5 Continents Editions: 88-7439-068-8

For 5 Continents Editions:

Translation
Susan Wise

Editing
Annie Van Assche

Art Director
Fayçal Zaouali

Editorial Coordinator
Paola Gallerani

Layout
Marina Longo

The paper for this publication has been kindly offered by:

TABLE OF CONTENTS

"THE MASTER WAS SKILFUL …
THE DISCIPLE STUDIOUS AND NIMBLE"*
Gigetta Dalli Regoli

The association of these three artists, Andrea del Verrocchio, Lorenzo di Credi and Francesco di Simone Ferrucci, is due primarily to the fact that the connection between them has been documented and this as well has been confirmed through philological and stylistic analyses.

Lorenzo, Andrea's pupil and fiduciary, took over management of the workshop when the master was absent, especially during his stay in Venice for the execution of the *Monument to Bartolomeo Colleoni*. Lorenzo was as well appointed by the master to serve as the executor of his will. The results of recent critical research further show that Francesco di Simone was connected with Lorenzo di Credi and with the administration of Verrocchio's workshop precisely between the years 1480 and 1490. Lorenzo may have also agreed to complete several unfinished works while Andrea was in Venice, and to take over some of the commissions for sculptural works that the atelier received, even while the leading person-in-charge was away.

Connecting the three personalities is also justified by the fact that the sheets attributed to them in the Département des Arts Graphiques of the Louvre offer particularly significant and rich examples of Quattrocento Florentine drawings.

Andrea del Verrocchio (ca. 1435/36–1488) and Lorenzo di Credi (ca. 1459–1537), master and pupil, lived and worked side by side, bound by feelings of respect and trust, although information drawn from various sources suggests that the two artists' personalities were utterly different.

Andrea was no doubt a spirited, dynamic man, and sharp to recognise among the youths of his time the gifted and the imaginative, and quick to obtain their collaboration, even for short-term interventions. He was widely trained in every field, and was able to use different techniques, including clay modelling, marble carving and processing, metal casting, and painting. A good organiser, he ran a very busy *bottega*, attended by versatile pupils prepared to experiment in the field of visual expression. In addition, it would seem that Andrea successfully challenged his competitors (in particular the well-established workshop of the Pollaiolo brothers, Antonio and Piero), and was willing to work beyond his usual sphere of activities, as we learn from his works produced outside of Tuscany, and from his move to Venice to carry out the *Colleoni Monument* commission. According to Vasari, he was cultured and interested in the sciences, especially geometry; but he must have been broadly cultured, since a document written after his death related to items he left behind mentions a small assortment of books, including Petrarch's *Triumphs* and Ovid's *Letters*.

In contrast, Lorenzo was first and foremost a

* Vasari 1568, vol. IV, p. 563.

draughtsman and a painter specialised in painting on wooden panels, a method that required a great deal of time, order, meticulous care and the preparation of materials. Although he may have briefly gone to Venice while Andrea was working there, or at the time of his master's death, he probably lived all his life in Florence. Recently, more attention has been devoted to the production of his art during his mature years, previously deemed a period of obvious decline. Yet, it cannot be denied that overall he was consistent throughout his career, and, even in the sixteenth century, essentially true to the course he set for himself during his youth.

Despite these explicit differences in character and habit, master and pupil worked together, and the famous *Sacra Conversazione* of the Pistoia Duomo (also known as the Madonna di Piazza) represents the apogee in the two artists' collaborations—the rich, composite culture of Verrocchio's *bottega* toward 1475. The question of spatial organisation, the importance of landscape, the interest in Flemish painting, and the expertise in the preparation of the colour *impastos* were blended together—indeed mastered—in the superb altarpiece, which doubtless had been designed by various members of the workshop, but subsequently studied in detail and executed solely by Lorenzo di Credi.

Very little of Verrocchio's extensive activities have been conserved, and even such major works as the *Colleoni Monument* or the *Forteguerri Cenotaph* (Pistoia) were not completed under his direct supervision. Regarding his drawings, the number of those we can attribute to him with reasonable confidence is extremely limited. In Lorenzo's case, the situation is quite different. Drawing for Lorenzo was a form of exercise and research that particularly suited his demands, and his sheets—a great number of which have come down to us—help us to clearly recognise the quality, most often outstanding, that he was able to achieve in this field.

Francesco di Simone Ferrucci (ca. 1437–1493), who belonged to a family of stone-carvers from Fiesole, was a sculptor active in Emilia, Tuscany, and the Marches between 1460 and 1490. His works include tombs, Madonnas, portraits, and sacred and profane furnishings, such as tabernacles and portals, lavabos and mantlepieces, in which he displays his mastery of a varied, elegant decorative repertoire. He appears in the present context because recent critics hold him to be responsible—at least in part—for a number of drawings and sketches of various dimensions (contained in sheets) that had originally been assembled in a so-called "workshop book"; a sketchbook that is undoubtedly connected with the Verrocchio/Lorenzo di Credi duo.

In the Quattrocento, especially in Florence and during the second half of the century, there was a great

deal of drawing and for various purposes. Just as the *sinopie* and several groups of drawings on parchment are evidence of widespread graphic activity during the Middle Ages, there is no doubt that during the fifteenth century the practice of drawing and the growing availability of paper developed concurrently, handing down to us a very vast and cohesive legacy.

These three artists would draw to design, that is, to plan a more or less complex composition; in a reverse process, they would also draw to copy or redesign, that is, to reflect on earlier accomplished, widely appreciated images, including antique monuments and excavation objects, and works by recent past and contemporaneous masters. They would draw, above all, to master the basic mechanisms of vision, and to create a specific, personal repertoire of forms: postures and movements of men and animals, draped fabrics, interior structures and landscapes, as well as flowers and leaves, heraldic figures and coats-of-arms, furnishing details, and elements of a person's garment or hairstyle.

The importance of the drawing practice within workshops can be inferred from a number of testimonies that have come down to us, but especially from the rare workshop books, nearly always now disassembled, identified by critics some time ago. The most well-known books are the sketchbook of Maso Finiguerra, and that of Benozzo Gozzoli and Verrocchio. The latter sketchbook, that of Verrocchio, was split up a long time ago between several famous collections and is preserved today in several of the most important, public, graphic art collections in the world. It can be dated to the years 1485–1490, and was probably taken apart and divided during the nineteenth century in France, since it is likely not a coincidence that the largest groups of sheets from these books are preserved today in the Département des Arts Graphiques of the Louvre and at the Musée Condé of Chantilly.

If we examine the style of drawing and the methods and materials used in the second half of the Quattrocento—obviously considering the most common ones—we are struck by their great variety. During the time of their execution, various "mixed techniques" were used, combining different substances and tools, making it sometimes difficult to identify their maker without the help of sophisticated methods of analysis. The artists used pen, charcoal, and black chalk—mostly on white paper—with drawings that were often the result of a direct, swift intervention that jotted down, aggressively, the most significant features of the image. The artists preferred metalpoints associated with white lead and tinted paper—paper just barely veiled with colour—for more elaborate figurations executed with patience and a light hand. The use of red chalk was, at this time, confined to preparatory outlining, or finishing and retouching. Aside from the graphic sign, done with either sharp and thin or soft points, the drawing could be integrated with a brush, either with white heightening in the prominent areas, or with bistre hatching, that is, with diluted ink applied in the hollows and cavities.

To draw the human figure, certainly the prevailing theme throughout the fifteenth century, the artists used live models, naked or dressed, as well as manikins made of wood, plaster or clay, upon which they would arrange fabrics that—permeated with wet clay or fat—were folded and modelled according to the requirements of the figures and their "stories". Reduced models of hands, feet, arms and legs were also very common.

Materials of this sort were commonly available in the workshops, and the basic elements were chosen, and eventually personalised, in connection with precise typologies—for example, the youth with the athletic build, sometimes featuring exaggerated limbs, muscles and posture, to suggest the image of a hero; the child, whose movements, lively and spontaneous, were

unconventional; the young woman with a slender build and light step—all being valid expressions for either sacred or profane "stories". The range of heads was more complex—those of elders, marked by a mesh of wrinkles, and those of children, well-fed and smiling. There were also "character heads" with strong bone structures, suited to characterise male figures, princes, condottieri, intellectuals and theologians. Obviously, each of these typologies are rooted in the classical figurative culture, revived by the growing interest in archaeological finds and their interpretations during the early Quattrocento.

Among the few works which can be confidently ascribed to Andrea, the sheet featuring, on the recto and on the verso, several sketches of nude *putti*, standing, lying down, and moving (pls. 2 and 3), bears an epigramme owed to a later hand—probably a sixteenth-century collector—that praises the sculptor, recalling the "equum mirandaque arte confectum", that is, "the equestrian monument to Colleoni". The images of children, practically identical but shown in different postures, present close likenesses with other Madonna works produced in Andrea's workshop in the 1570s, works that were done in collaboration with highly qualified, albeit young artists in their early years (Botticelli, Perugino, Ghirlandaio, Credi). There is an even more cogent connection with Leonardo's youthful drawings, specifically those connected with the theme of the *Madonna of the Cat*. Vasari's life of Andrea contributes further elements, along with the mention, among his widely appreciated goldsmithery artworks, of a bowl "dove è un ballo di puttini molto bello" ("where there is a very handsome dance of *puttini*"). The particular quality of the design of the nine pen-traced figures, flowing and discontinuous in the profiles as well as in the definition of the hairstyles, brings to mind the modelling of pliable materials, such as clay, wax, and stuc-

co, and almost seems to reproduce the constant shifting of the image under the sculptor's hand.

The problem of intervention within Verrocchio's workshop, and of the difficulties in distinguishing the collaborators' contributions, is clearly exemplified by the *Female Head* (pl. 1) representing a young woman with regular features, lowered eyelids and wavy hair with a few stray locks. The image is formed by a mobile mesh of very thin, white and dark grey lines on an orange-red base, representing one of the most stunning results achieved by a drawing on tinted paper in Florentine circles of this time. The typology is comparable to several Madonnas from Verrocchio's circle, but except for the veil coming to a point on each side and on the brow (perhaps added to a first version, as Françoise Viatte pointed out), the closest comparison appears to be Leonardo's *Madonna with a Carnation*, now at the Alte Pinakothek in Munich. The sinuous waves of the hair, the brooch, and the narrow fur trimming along the neckline underscore the mundane mood of this young woman, and well suit the spirit of this painting executed by an ambitious youth whose aim was to demonstrate herein his possession of vast cultural assets. The rich garment, the mantle with the yellow lining, displayed in the foreground with an "abstract drapery", the glass vase holding a bouquet of flowers—anticipating a genre that was to become very popular in the sixteenth and seventeenth centuries—lead us to think that this may well be the young Leonardo's *Madonna* which according to Vasari was in Rome in the possession of the pope Clement VII: "… e fra l'altre cose … contraffece una caraffa piena d'acqua con alcuni fiori dentro … dove aveva imitato la rugiada dell'acqua sopra, sì ch'ella pareva più viva della vivezza" ("… and among other things … it emulated a pitcher full of water with some flowers … where he had imitated its dewy surface, so that it looked more alive than

life itself"). While it may be difficult to say whether the study of the Louvre work is by Andrea or by Leonardo, in my opinion, it is closely connected with the latter, especially the famous *Divine Head* of the Gabinetto Disegni e Stampe of the Galleria degli Uffizi (inv. 428 E), which has an ascertained Da Vinci autograph.

The heads of youths and elders by Lorenzo di Credi, which the Louvre's Cabinet des dessins possesses in profusion, are more modest and simple: plainly-dressed figures, fellow workers and neighbours, or portrait sitters that, before proceeding to the painted version, were represented on paper in an intimate, natural manner. The faces, with their regular features, fail to betray emotion, and the gaze is either hidden or barely filters through the lowered eyelids; occasionally the neck is slightly arched, the eyes staring at a remote point as if in anticipation. Lorenzo di Credi clearly seems to approach the figures in his portrait heads trustingly, establishing a cordial relationship with them. This is especially apparent in his representation of elders, even when the artist portrays, without indulgence, the slack contours of the face, the aging skin, the thinning, even dishevelled, hair.

It has already been mentioned that drawings were often a preliminary gesture for subsequent pictorial or plastic elaborations. There is one such excellent example of a preparatory study in the *Saint John the Baptist* (pl. 28), a first essay by Lorenzo di Credi for the figure of the Saint in the earlier-mentioned Madonna di Piazza (in the Pistoia Duomo).

The figure respects traditional iconography, in which the precursor, Saint John the Baptist, points at the Child. But here the artist proceeded gradually and with some hesitation, completing several parts and leaving others just barely outlined and with a number of corrections or variants. The result has been interpreted as proof of double authorship: Verrocchio for the attitude of the figures, and Credi for the garments. Instead, this author believes that the work belongs entirely to Lorenzo, fully revealing his weaknesses and strengths—for example, the joining of the legs with the torso is not entirely resolved, just as with the painting. In addition, there is a certain lack of art in the face to evoke the Saint's hermitic retreat—the hollow eyes and deep creases at the corners of the mouth, which, along with the leather girdle with its frayed border and the long hair, moreover combed in long curls should suggest it. On the other hand, the artist is quite at ease with wrapping the figure in an ample mantle, softly draping it. Its delicacy is summed up in the spiralling hem that falls to the ground—small but excellent proof of Credi's skill in creating a three-dimensional form.

Lorenzo di Credi displays the same fondness for drapery in the large sketch for a *Saint Bartholomew* (pl. 29), which presents a different solution from the artist's painting of the same subject for the church of Orsanmichele in Florence. In the wooden panel, the colour arrangements and marginal adornments make the Saint's garb more attuned to the current taste, whereas the body in the sketch is a mere, faint outline onto which is amassed an amply-draped mantle with deep folds. The combination of tempera, oil and white lead on a dark ground in this work produces effects of intense relief, and duplicates Leonardo's and Fra Bartolomeo's more original "thickened fabrics" ("panni rappresi", i.e., fabric permeated with or dipped in plaster).

A few years after completion of this work, Lorenzo would successfully measure himself with the nude, as attested by the magnificent *Venus* of the Uffizi, recently restored, in which the delicacy of the modelling has been retrieved. Moreover, the Louvre collection of drawings contains another piece of evidence that may well be representative of Credi's more mature works—the *Study of a Nude* (pl. 38) may have been done for the

Flagellation of Christ or *Saint Sebastian*, albeit shown only in the central part of the body. Unlike what occurs in a complete image of the human figure, where usually the face, hands and feet are the first to draw one's attention, in this drawing the absence of the head and a large section of the limbs allow one to fully grasp the exquisiteness created by the curve of the body, the tension of the shoulders and the contraction of the chest muscles. While there remains some uncertainty as to its attribution, although there are numerous references to Lorenzo, the drawing moreover reveals some links with the activities of Baccio della Porta, in other words, Fra Bartolomeo. It will be mentioned here, only briefly, the fact that the morphological structure of the nude recalls that of Saint Sebastian in the Malatesta altarpiece of the museum of Rimini—an unfinished painting by Domenico Ghirlandaio done at the end of the century and completed by several of his collaborators and pupils, among whom precisely Baccio della Porta played an important role.

It has already been mentioned that on Verrocchio's departure for Venice, Lorenzo di Credi was left in charge of running the atelier, and that, almost certainly for the sculptural works, he called upon Francesco di Simone Ferrucci for assistance. Notwithstanding, Credi must have also, in some measure, shared in the designing of architectural, three-dimensional works, collaborating with Francesco di Simone in creating monuments, altars, chapels, and ciboria.

The sheet that evidences this relationship (pl. 44) comes from the collection known as *Libro dei disegni*, an impressive group of drawings that Giorgio Vasari assembled in the first half of the sixteenth century and arranged in book form, probably consisting of a number of volumes, pasting the drawings onto the pages and altering them in several ways—sometimes cutting them, combining them to form compositions, and placing them in elaborate, diversified forms of frames. In the Louvre drawing, the mount is only slightly invasive, although the original drawing has been integrated, especially at the top and bottom (see the cartouche featuring the author's name), and likely partly retouched.

This drawing is a design for a sepulchral monument, consisting of an urn decorated on the surface and closed by a lid, upon which stand three statuettes—Justice in the middle, and Temperance and Fortitude on either side, with two *putti* on the base upholding a coat-of-arms, too simplified and schematic to allow their identification. The style of the tomb and its graphic outline show likenesses with a series belonging to Credi's late career, a time when the painter alternated drawing on tinted paper with a silverpoint, as he was fond of doing in his youth, and drawing with a pen on white paper, usually shadowed with bistre, but sometimes with black chalk and red chalk. These are extremely precious and fully-accomplished sheets, datable between the late-fifteenth and the early-sixteenth centuries. In several, there are hints of the presence, in Florence, of the youthful Raphael and the burgeoning "bella maniera" of the time. They also, however, present a delicate problem of attribution, since here Credi's works are interwoven with those of Piero di Cosimo and Fra Bartolomeo.

The pen execution, the broad, easy strokes, and the frequent use of hatching that can be found in Credi's *Study for a Tomb* characterise in large measure the numerous sketches drawn on the leaves of Verrocchio's sketchbook. It would seem that the differences and the uneven quality observed in these sheets are not simply owing to the fact that the drawings may or may not be accomplished. Several individuals, in fact, worked on these sheets, with different means and likely at different times, leaving behind not only images, but also written notes with various contents, and fortunately in

some cases, dates providing a likely time frame for the ensemble of between 1485 and 1490.

The loose sheets of this sketchbook, presently distributed among various locations, are thronged with figures of men and animals, Madonnas, *puttis*, knights, saints and angels, but also heads, details of figures and physiognomies, and capitals and friezes. We can recognise, although with some hesitation, references to well-known works by Verrocchio (ex., Putto *with a Dolphin*, cf. pl. 3), Antonio Pollaiolo (*Hercules and the Hydra*, cfr. pl. 14) and Lorenzo di Credi (*Madonna and Child and the infant Saint John* of the Galleria Borghese), as well as those of other masters, mainly sculptors, such as Desiderio da Settignano and Mino da Fiesole, and, more exceptionally, copies after medals and classical fragments (ex., emperors' profiles, a nymph riding a sea-god; cf. pls. 20 and 22).

The value of these "figurative notes", drawn while continuously turning the sheet as it is being worked, and featuring simple, schematic sketches that are exercises and exemplifications with a didactic intent, or more rarely original episodes, lies mainly in the constantly revisited typologies and themes—*putti* upholding a cartouche, angels upholding a mandorla and candelabra, an infant Jesus and an infant Saint John, the adult John the Baptist pointing toward a hypothetical Christ, Saint Jerome with the penitential stone, Saint Sebastian with the archers, Saint Francis, Saint George on horseback, a victorious David, Marsyas, Nessus and Deianira, and a recumbent young woman, perhaps Venus, perhaps Ariadne or a nymph. These qualify the ensemble as a wide-ranging work tool, that is, pragmatically-oriented toward an intense, average-quality activity, to be elaborated with the contribution of various artists—masters and disciples—endowed with good professional training and used to working within the bounds of well-established traditions. Furthermore,

these features distinguish Verrocchio's sketchbook from those notebooks which present an outstanding antiquarian interest, such as the famous *Codex Escurialensis* (El Escorial, Bibl. Cod. 28-II-12).

The quality of the individual drawings, as has already been mentioned, is uneven, either because they were connected from time to time with interventions of a certain importance and at other times with hazy recollections jotted down with no particular aim, or because different artists were involved in their execution.

In some of the drawings that were traced with a sure hand, close in some regards to Leonardo's youthful drawings, it may also be possible to make out the episodic presence of Andrea del Verrocchio, Lorenzo di Credi, or other masters, such as Francesco di Giorgio Martini, whose name has been brought up in the past because of certain analogies in the definition of the image by the graphic sign (Ragghianti 1967). Instead, a number of the quickly-executed and roughly-outlined figurines very likely belong to Francesco di Simone, while other sketches done in a more cursive style, some of which are definitely weak and laboured, may belong to unknown collaborators and apprentices.

The value of these authentic handbooks of images—easily passed around, from one place to another, and from one artist to another—can be best illustrated by a specific case that has recently been evidenced. In the lower corner of the sheet RF 447 (pl. 16), there is a *Prisoner*, that is, a male figure with his hands bound behind his back and leaning forward, as if to break away from the invisible element restraining him. The formula for this work is analogous to the one appearing in a drawing by Raphael datable to around 1510 (Vienna, Albertina), and for this reason it has been suggested that Raphael may have consulted Verrocchio's sketchbook. This prisoner is, in fact, a famous model whom Francesco di Simone and Raphael may have seen and

studied in Urbino, although possibly at different periods: the bronze plate of the *Flagellation* (1480–1485; Perugia, Galleria Nazionale dell'Umbria) by Francesco di Giorgio Martini, whose name has already appeared here, perhaps executed for a patron from Urbino. The validity of these Raphaelesque "lead" is supported by further analogies with the *San Sebastian* by Sodoma (Galleria degli Uffizi).

Unfortunately, much of the intercourse between the artists' studies and experiments, upon which their works were based, has been lost. Only in sections, and even then sporadically, can we grasp one of these passages, and here again Verrocchio's sketchbook offers additional examples.

In the group of drawings belonging to the Louvre ensemble, several stand out for both their quality and their connections with paintings and sculptures. Such is the case with the delicately-hatched *Child's Arm*, separated from the rest of the body, featured on the sheet RF 450 (pl. 21). This work is a detailed study for a figure of Jesus who is grasping a piece of light fabric and holding it in his chubby hand. This work was likely taken from one of the more elegant and precious Madonnas produced by Verrocchio's workshop, the *Madonna* in the Gemäldegalerie of Berlin (inv. 108). This detail appears again, with variants, in other Madonnas executed in the same circle (in the Frankfurt and Edinburgh Museums), and in both drawings and paintings by Lorenzo di Credi.

In contrast, a *Male Nude* with hands on hips (pl. 23) recalls variations on the theme of David victor of Goliath, that was especially popular in Florence. The youthful male offers several alternatives to a specific model—the bronze statue at the Bargello museum—one of Andrea del Verrocchio's most famous works. This work was formerly in the property of the Medicis and later prominently placed among the furnishings of Palazzo della Signoria. Stripped of the elegant tunic Andrea had given the biblical hero, this nude displays a more solid frame, but tends to accentuate the "pose", perhaps owing to a more up-to-date style related to highly successful formulas devised by Perugino: Donatello's and Verrocchio's immature adolescents had grown stronger and more self-confident. Also apparent in this work is a major contribution to the evolution of the youthful Quattrocento *David* into Michelangelo's robust, mature *Giant*.

Chronology

Andrea del Verrocchio

1435–1436
> Andrea di Michele Cioni, known as Andrea del Verrocchio, is born in Florence.

1453–1456
> Verrocchio trains with the goldsmith Antonio di Giovanni Dei.

1465 Verrocchio begins the *Sepulchral Monument of Cosimo de' Medici* at San Lorenzo. He also executes a *Putto with a Dolphin* for the Villa Medici at Careggi (Florence, Palazzo della Signoria, Quartiere degli Elementi).

1466 He receives the commission for a bronze group, the *Incredulity of Saint Thomas*, for the niche of the Arte della Mercanzia, located outside Orsanmichele (Florence), that will be installed in 1483.

1472 Verrocchio completes the *Sepulchral Monument of Piero and Giovanni de' Medici* at San Lorenzo (Sagrestia Vecchia). Between the years 1472 and 1475, he completes the bronze *David* commissioned by the Medicis (Florence, Museo Nazionale del Bargello).

1478 Verrocchio is engaged to create the *Forteguerri Cenotaph* for the Pistoia Duomo (that he will not complete).

1480 He carves the relief of the *Beheading of Saint John the Baptist* (Florence, Museo dell' Opera del Duomo), and probably around this same time, the *Lady with the Bouquet of Violets*, the polychrome terra-cotta lunette for the *Resurrection of Christ*, from the Villa Medici of Careggi, and the marble relief for the *Death of Francesca Tornabuoni* (Florence, Museo Nazionale del Bargello).

1481 Verrocchio presents the *Model for the Equestrian Monument of Bartolomeo Colleoni*, which was commissioned by the Republic of Venice for the Campo Santi Giovanni e Paolo.

1483 Verrocchio permanently leaves Florence and goes to Venice to execute the *Colleoni Monument* in bronze.

1488 Still in Venice, Verrocchio writes his will on 25 June. He designates Lorenzo di Credi as sole heir to his estate, and requests that the completion of the *Colleoni Monument* be entrusted to him; it was to be completed by Alessandro Leopardi in 1495.

Francesco di Simone Ferrucci

Circa 1437
> Francesco Ferrucci, known as Francesco di Simone, is born in the town of Fiesole (Florence). He begins to study sculpture with his father, Simone di Nanni, and later with Desiderio da Settignano.

1460–1463
> Francesco works on the carved decoration of the Badia of Fiesole. On 29 January, 1463 he becomes a member of the Arte dei Legnaioli e degli Scalpellini, in Florence.

1466–1467

Francesco opens his first workshop in Florence, Via de' Servi. At the end of 1466 and the beginning of 1467 he likely resides at Forlì to sculpt the *Monument of Barbara Manfredi* (San Mercuriale). The other works executed by him in the Forlì area include the *Tomb of Sigismondo Malatesta*, at Rimini (Tempio Malatestiano).

1468 Francesco's name is mentioned in the records of SS. Annunziata (Florence) in connection with works executed, in collaboration with his brother Bernardo, in the church as well as in the convent (work on the church grounds lasts until 1478).

1471–1472

Francesco executes the *Sepulchral Monument of Lemmo Balducci*, in Florence (Spedale di San Matteo, now partially preserved at Sant'Egidio).

1476 Francesco works in the Cathedral of Prato; his activity there in 1485 and 1487 is also documented.

1477 Possibly during this year, he may have begun his collaboration with Andrea del Verrocchio, for whom he likely executes part of the *Tomb for Francesca Pitti Tornabuoni* (Rome, Santa Maria sopra Minerva; today disassembled and partially lost). Concurrently, he works on the *Tomb of Alessandro Tartagni* (Bologna, San Domenico).

1480 At Bologna, Francesco carves some bas-reliefs for the façade of San Petronio, as well as the tombs of Vianesio Albergati and Pietro Fieschi, for the church of San Francesco.

1482 Francesco executes the *Tomb of Pietro Minerbetti*, in the church of San Pancrazio, in Florence (now disassembled).

1483 Francesco executes a ciborium for the church of Santa Maria di Monteluce, at Perugia.

1485–1488

Francesco sculpts the tombs of Giovanni Francesco Oliva and of Marsabilia Trinci (San Francesco at Montefiorentino in Piandimileto, near Pesaro). He works for the Duomo of Florence in 1487.

1491–1492

Francesco again works for the Opera del Duomo in Florence.

1493 Francesco dies in Florence; he is buried in the church of San Pier Maggiore, now demolished.

Lorenzo di Credi

Circa 1459

Lorenzo di Credi is born Lorenzo d'Andrea d'Oderigo in Florence. He receives his first training from his father, a goldsmith, Andrea Sciarpelloni.

1470–1480

Lorenzo joins the workshop of Andrea del Verrocchio, alongside Pietro Perugino, Sandro Botticelli and Leonardo da Vinci.

1481 Verrocchio is given the venetian commission for the *Equestrian Monument to Bartolomeo Colleoni*; the master will leave Lorenzo in charge of the workshop.

1485 Lorenzo executes the *Enthroned Madonna with Saints* (*Sacra Conversazione*) for the oratory of the Vergine in Piazza in Pistoia (presently in the Cathedral), a work commissioned to his master Verrocchio. This altarpiece is related to the *Saint Donatus of Arezzo and the Tax Collector* (Worchester Art Museum, Massachusetts) and the *Annunciation* (Louvre).

1488 Andrea del Verrocchio dies, and Lorenzo, as his heir and executor of estate, is in charge of completing the statue of Colleoni. He engages Giovanni d'Andrea di Domenico to execute this work; it was to be completed by Alessandro Leopardi in 1495.

1490–1493
 In Florence, Lorenzo paints the *Madonna Enthroned between Saint Julian and Saint Nicholas* (Louvre) in the church of Santa Maddalena de' Pazzi, installed on 20 February, 1493.

Circa 1500
 Lorenzo executes the *Adoration of the Shepherds* for the church of Santa Chiara, in Florence (Galleria degli Uffizi), commissioned by the Florentine merchant Jacopo Borgianni. Lorenzo looks to the paintings of Fra Bartolomeo, Raphael and Andrea del Sarto. The influence of these artists is obvious in the *Baptism of Christ* (San Domenico, Fiesole), the *Adoration of the Infant Jesus* for the SS. Annunziata (Galleria dell'Accademia, Florence), and the *Crucifixion* (perhaps intended for San Pier Maggiore (Göttingen).

1501 He is engaged to restore the *altarpiece* by Beato Angelico at San Domenico (Fiesole).

1504 Lorenzo serves on the committee that decides on the location of the *David* sculpted by Michelangelo (Florence, Galleria dell'Accademia).

1510 Lorenzo receives an advance for the *Virgin and Saints*, painted for the Ospedale del Ceppo of Pistoia (Museo Civico).

1515–1516
 For the Compagnia di San Sebastiano presso lo Scalzo, Lorenzo paints the *Virgin with Saint Sebastian and Saint John the Evangelist* (Dresden, Staatliche Kunstsammlungen).

1520 Lorenzo retires to the convent of Santa Maria Nuova, in Florence.

1526 The *Saint Michael Archangel* in the Sacrestia dei Canonici at Santa Maria del Fiore is one of Lorenzo's last works. He gradually gives up painting.

1537 Lorenzo dies in Florence.

PLATES

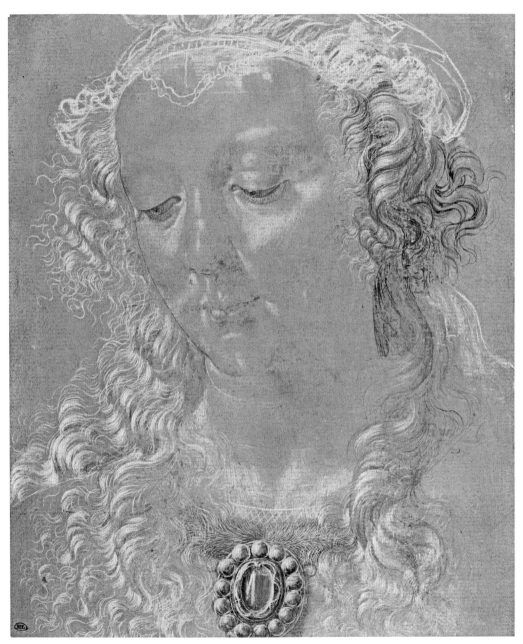

1. Verrocchio (or Leonardo ?), *Female Head*

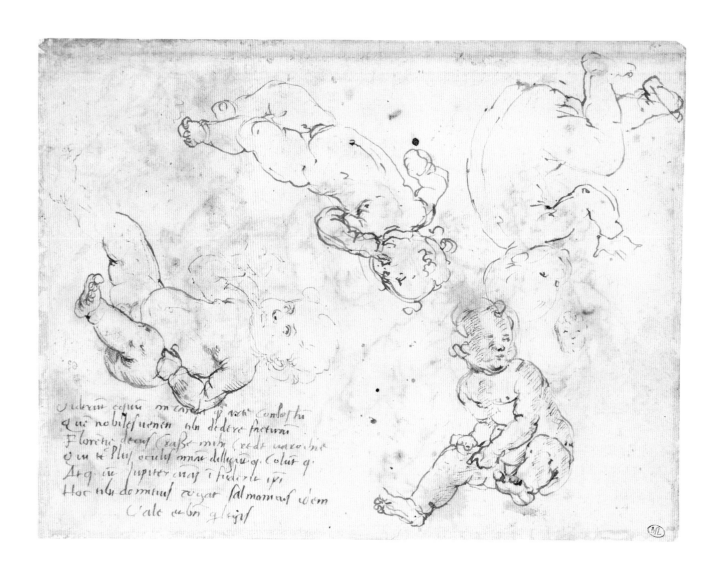

2. VERROCCHIO, *Four* Putti *and Sketch of a Head*

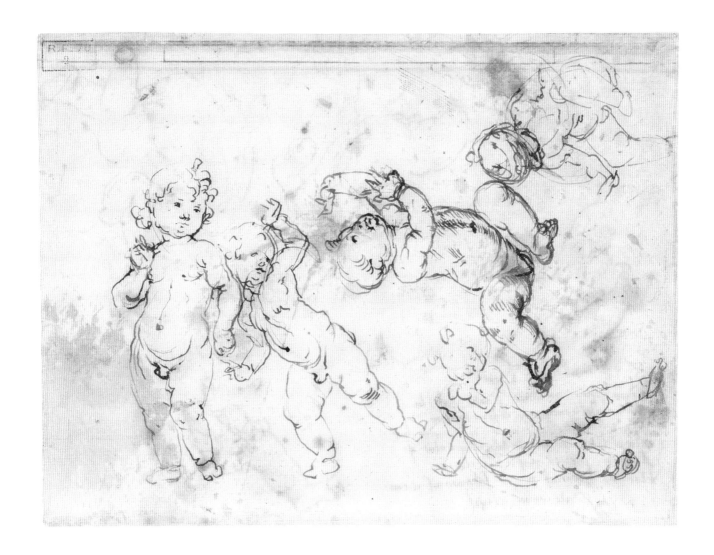

3. VERROCCHIO, *Five* Putti

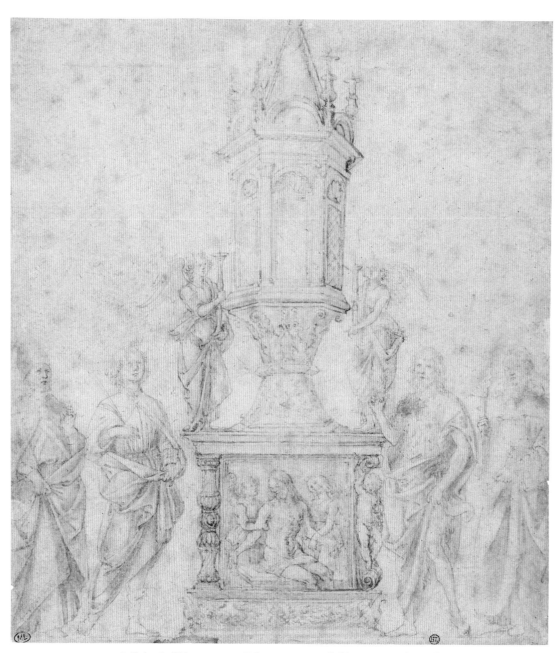

4. School of Verrocchio, *Reliquary surrounded by Saints and Angels*

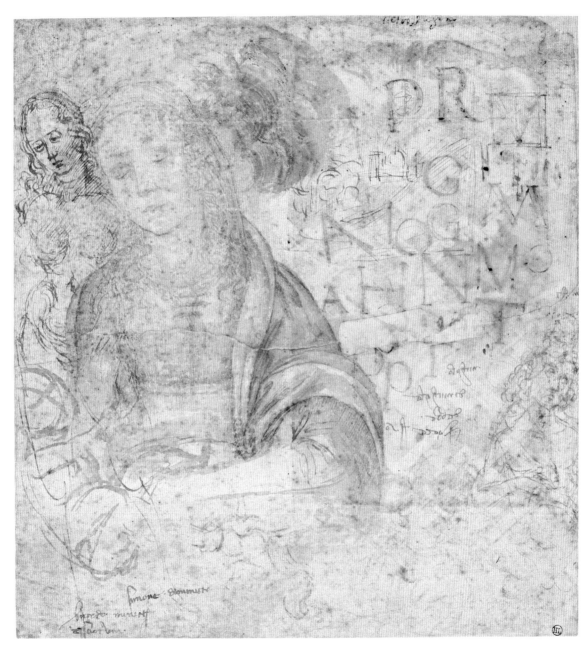

5. School of Verrocchio, *Madonna and Child and other studies*

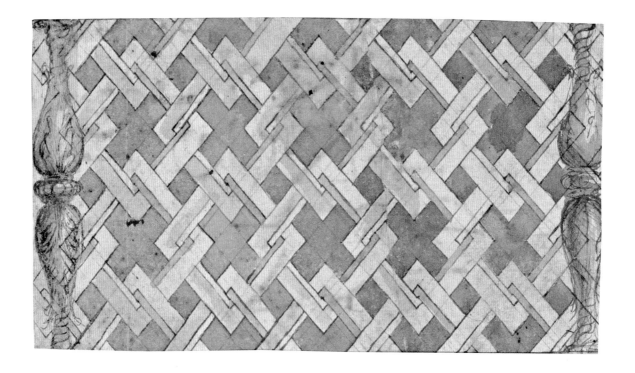

6. School of Verrocchio, *Interlacing between two balusters*

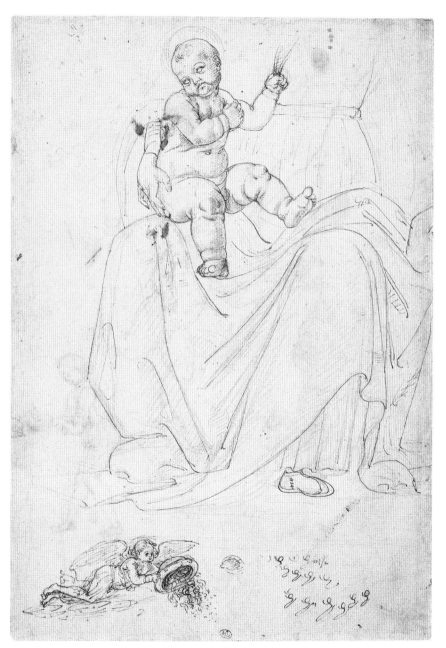

7. FRANCESCO DI SIMONE, *The infant Jesus on the Madonna's lap and other studies*

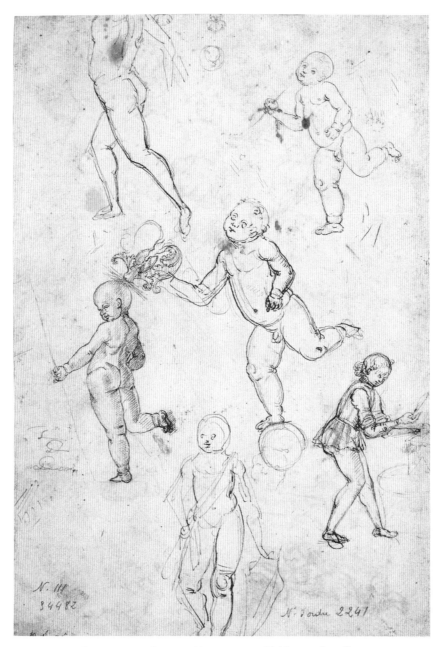

8. Francesco di Simone, *Man running; Children and small* Putti

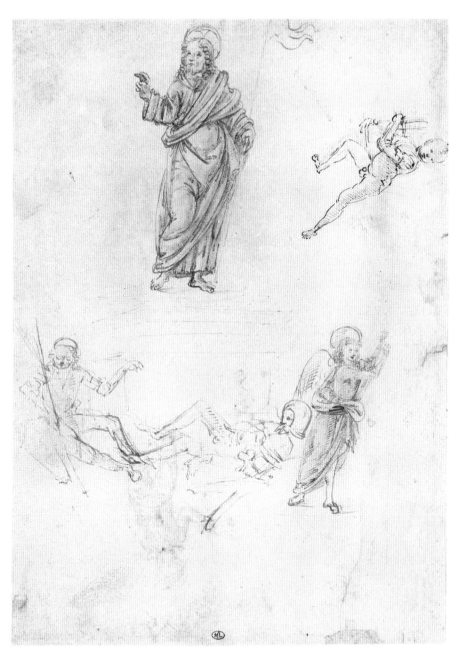

9. Francesco di Simone, *Resurrection of Christ and other studies*

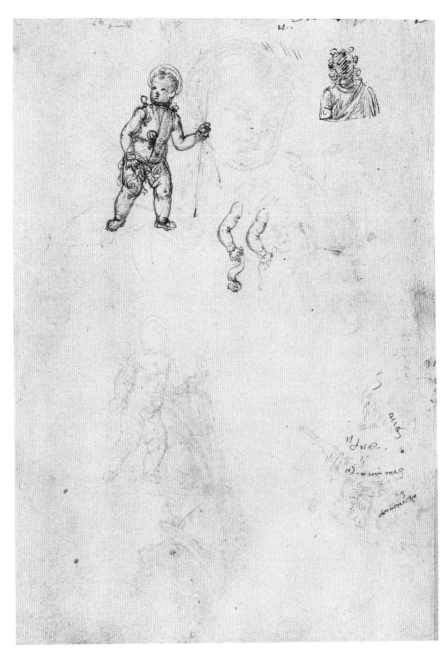

10. FRANCESCO DI SIMONE, *Infant Saint John and other studies*

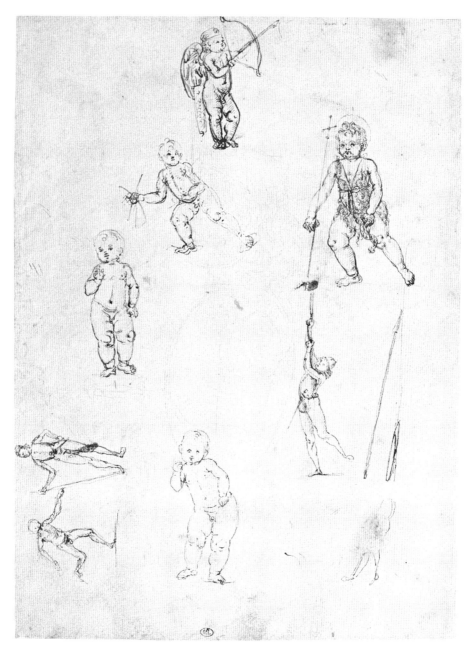

11. Francesco di Simone, *Cupid; Infant Saint John and various figures*

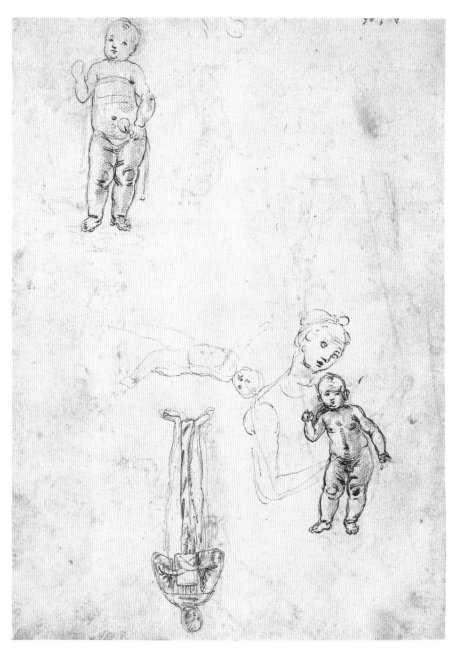

12. FRANCESCO DI SIMONE, *Madonna and Child; Standing Monk and other studies*

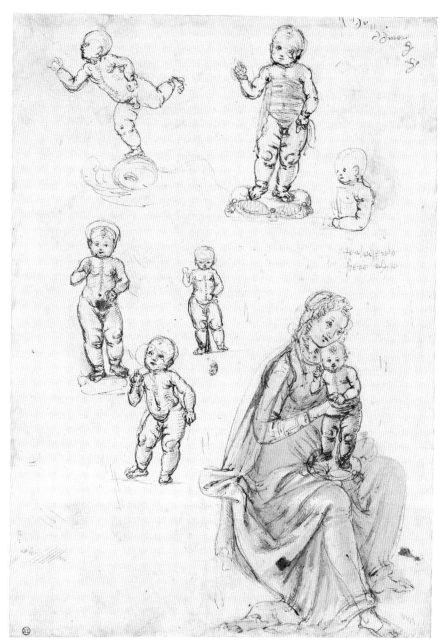

13. Francesco di Simone, Putto *on a dolphin; Madonna and Child and other studies*

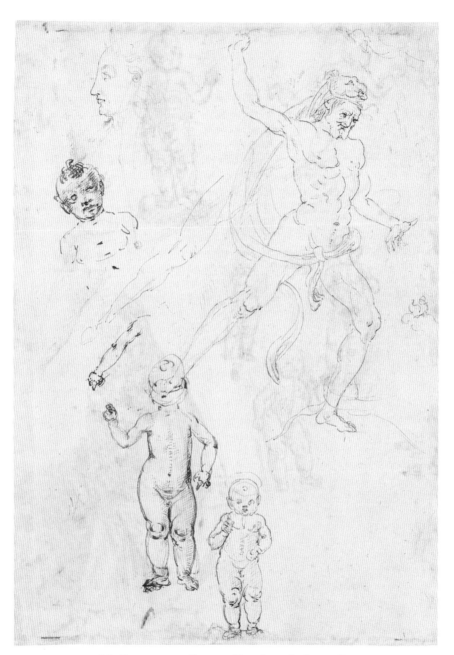

14. Francesco di Simone, *Hercules and other studies*

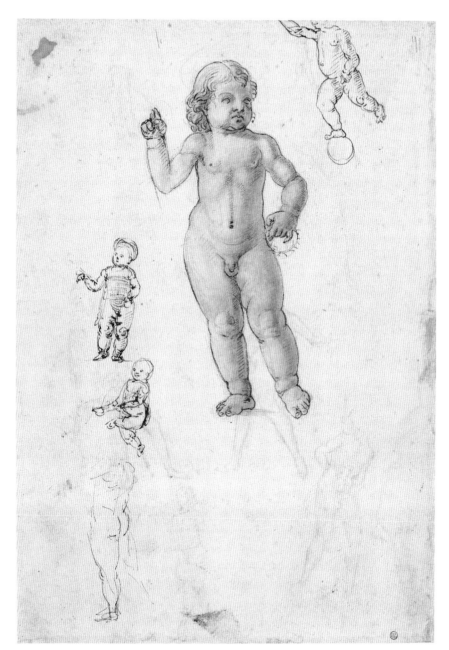

15. Francesco di Simone, *Christ Child blessing*

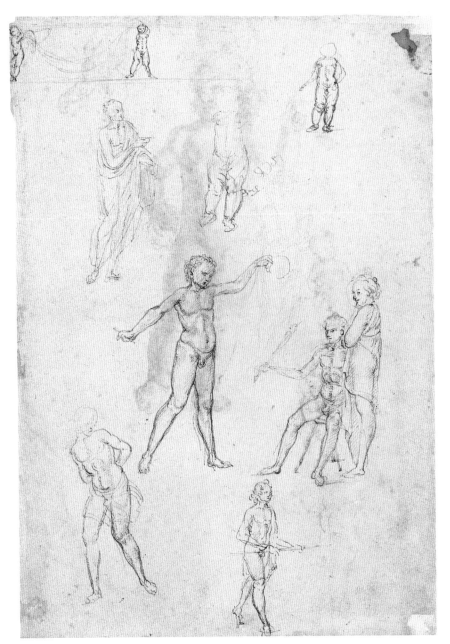

16. FRANCESCO DI SIMONE, *Relief of a Sarcophagus; Christ in bonds and various figures*

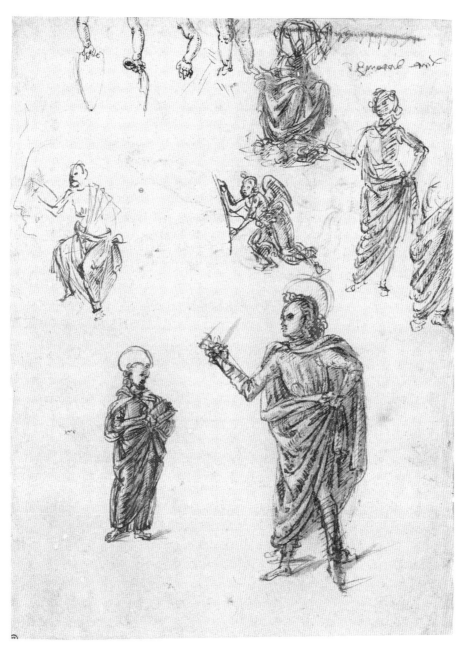

17. FRANCESCO DI SIMONE, *Coronation of the Virgin (?) and other studies*

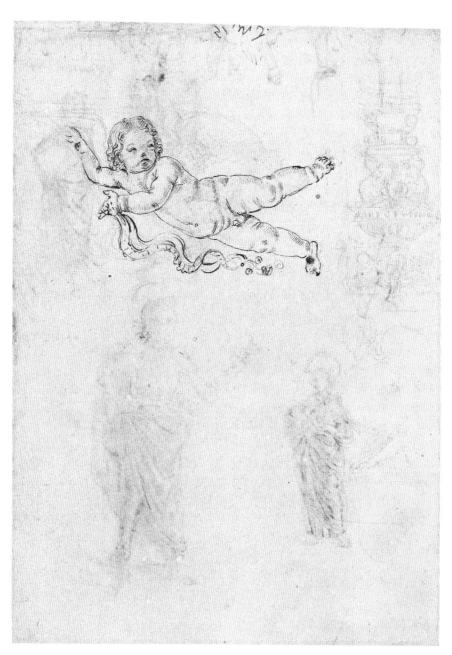

18. Francesco di Simone, *Child with a banderole; Candelabra; Harpy*

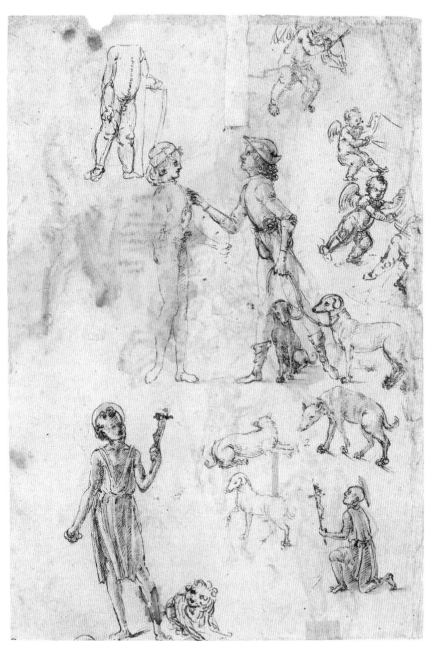

19. Francesco di Simone, *Youth in conversation with a Hunter and other studies*

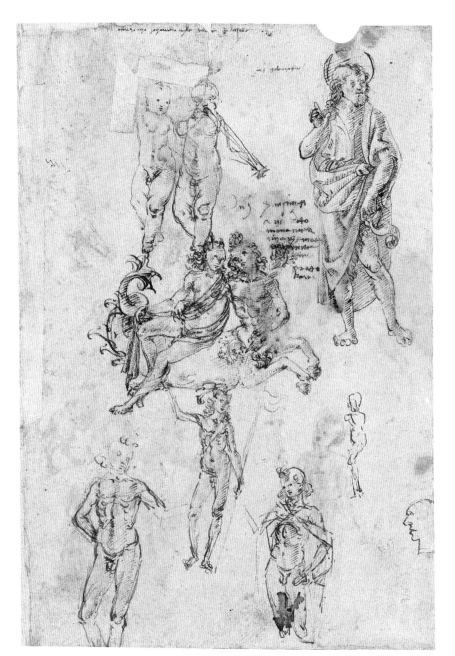

20. FRANCESCO DI SIMONE, *Sea Centaur with a Nymph and other studies*

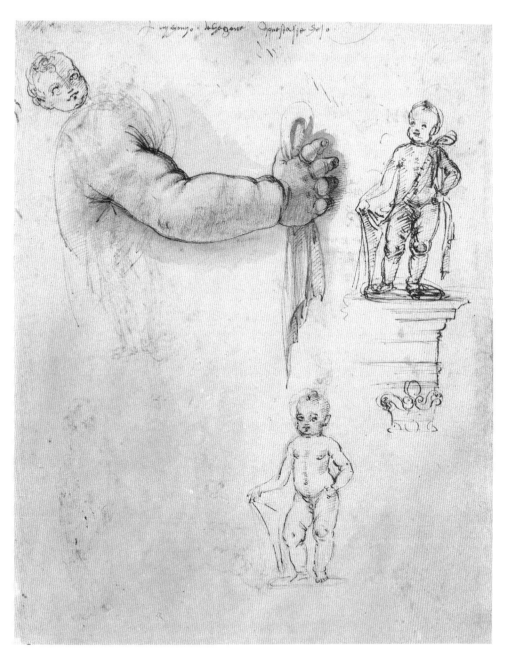

21. Francesco di Simone, *Arm of a Child; Putti with a shield*

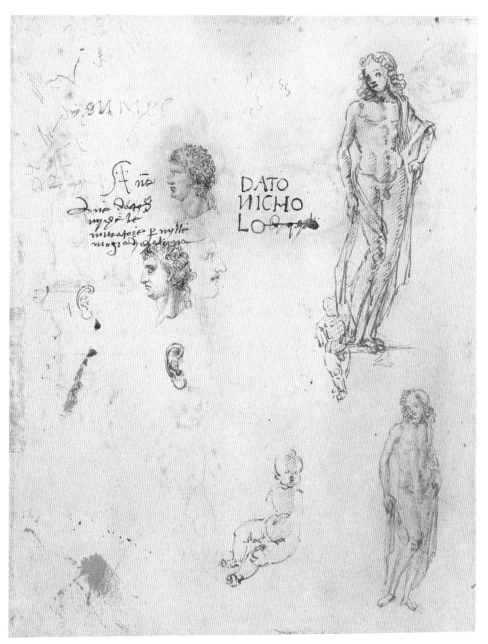

22. Francesco di Simone, *Apollo (?); Profiles after antique medals and other studies*

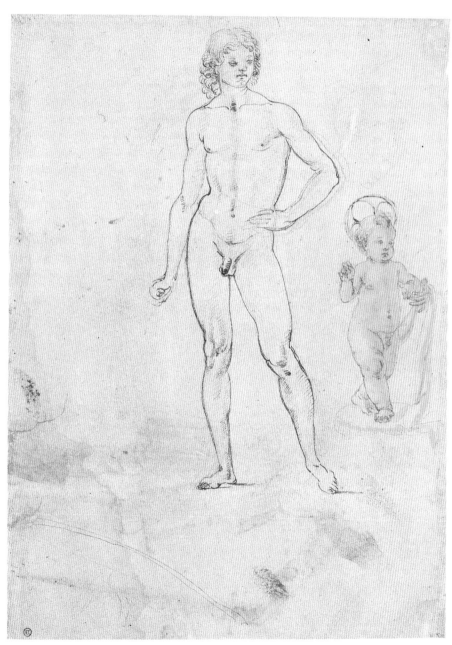

23. Francesco di Simone, *Nude Youth; Child blessing*

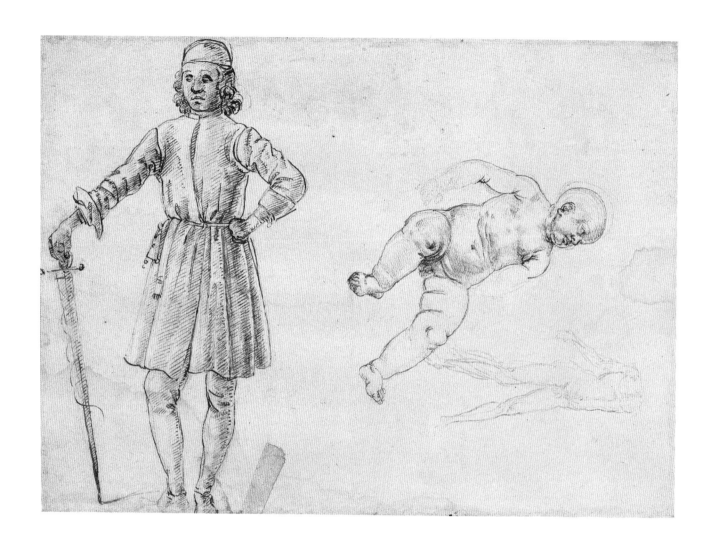

24. Francesco di Simone, *Standing Man leaning on a sword and other studies*

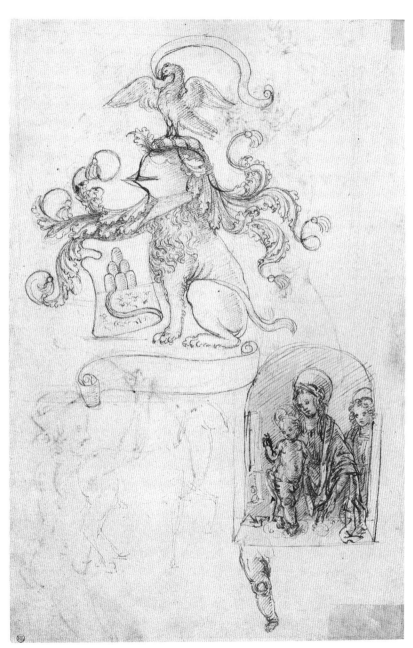

25. Francesco di Simone, *Coat-of-Arms and other studies*

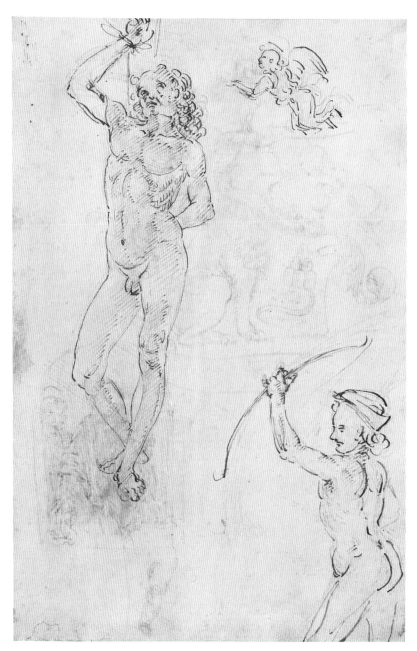

26. FRANCESCO DI SIMONE, *Studies for the Martyrdom of Saint Sebastian*

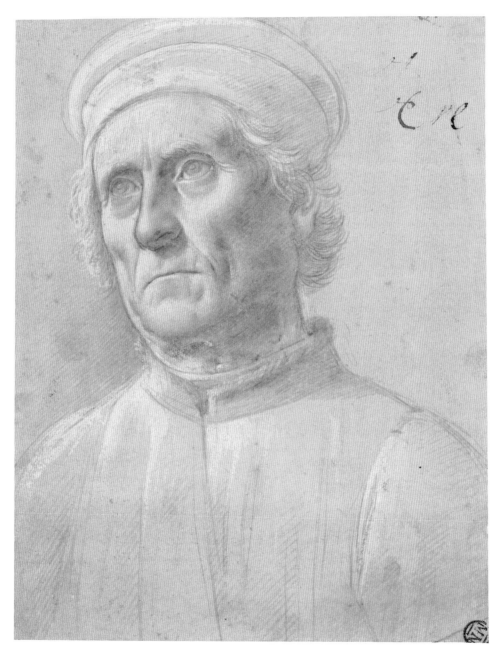

27. LORENZO DI CREDI, *Man, half-length*

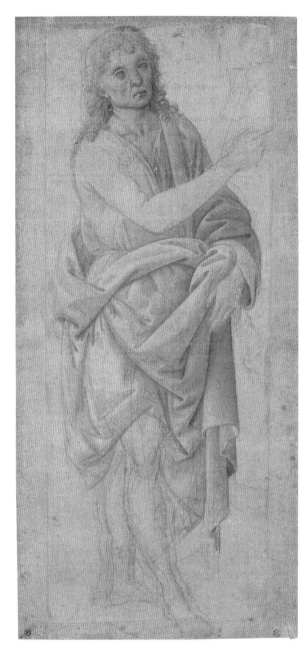

28. LORENZO DI CREDI, *Saint John the Baptist*

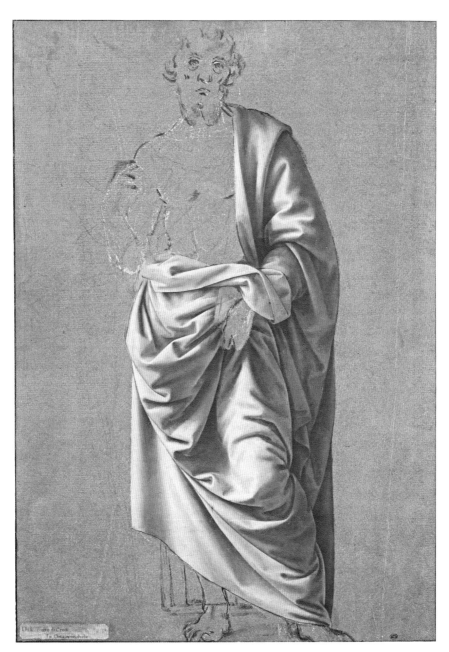

29. LORENZO DI CREDI, *Drapery for Saint Bartholomew*

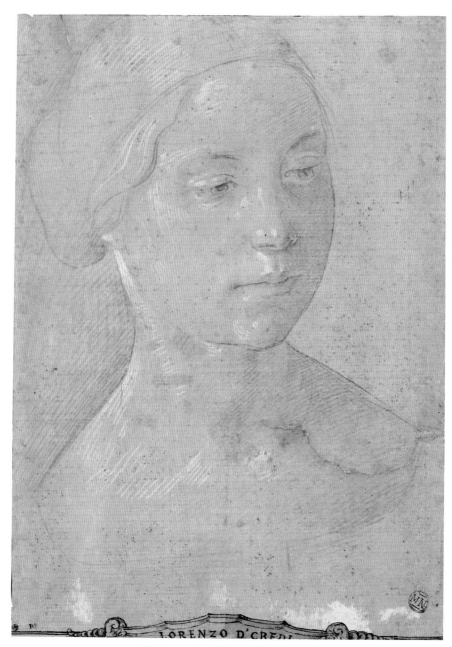

LORENZO D'CREDI

30. LORENZO DI CREDI, *Female Head*

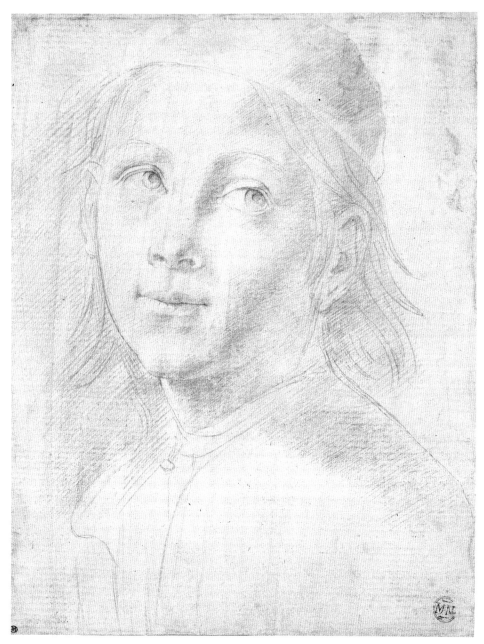

31. Lorenzo di Credi, *Head of a Youth*

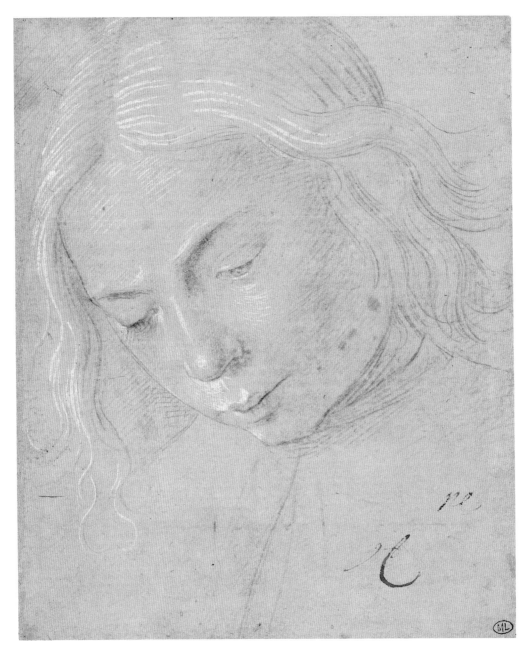

32. Lorenzo di Credi, *Head of a Youth*

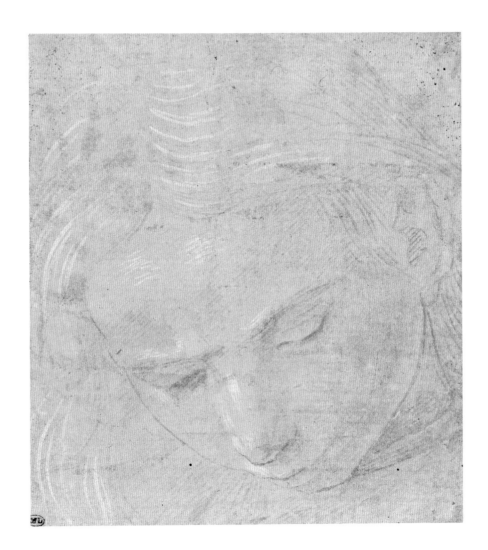

33. Lorenzo di Credi, *Head of a Youth*

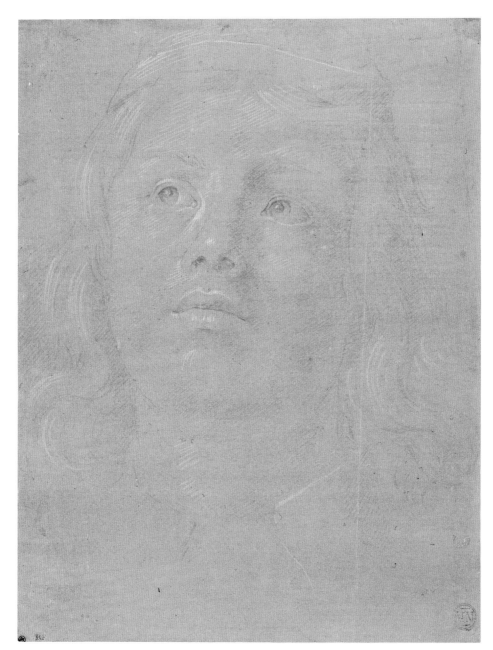

34. Lorenzo di Credi, *Head of a Youth*

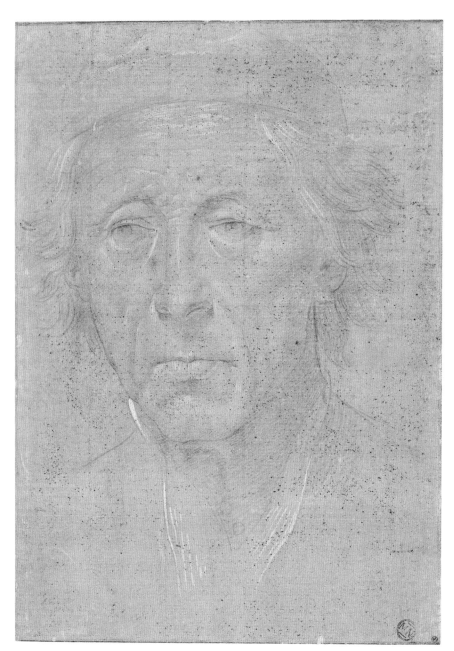

35. Lorenzo di Credi, *Head of an Elder*

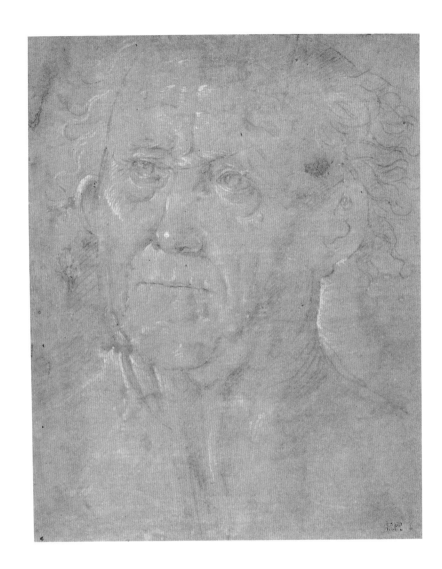

36. Lorenzo di Credi, *Head of an Elder*

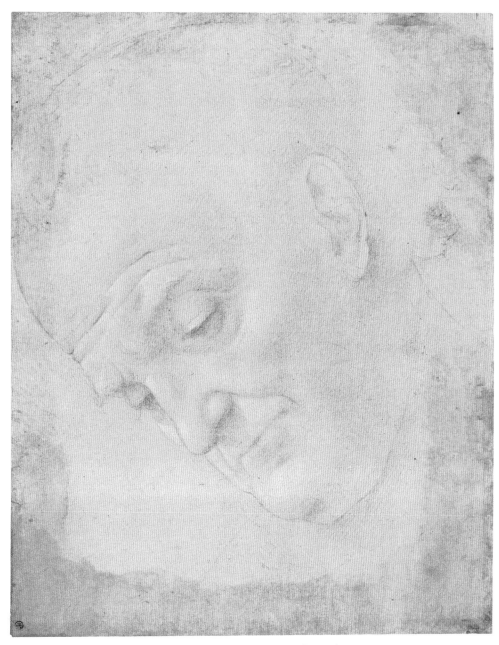

37. LORENZO DI CREDI, *Male Head*

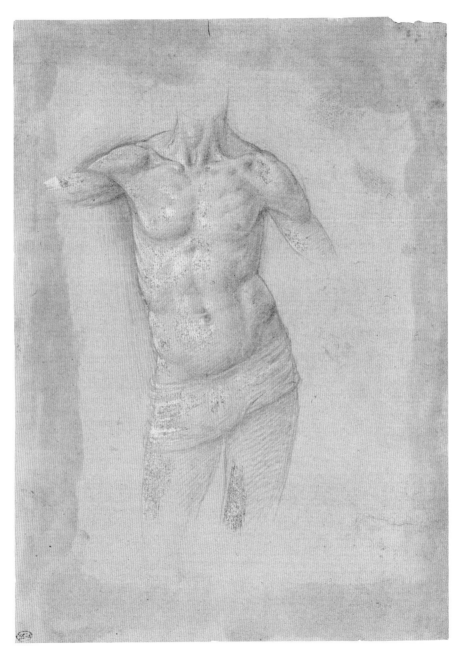

38. LORENZO DI CREDI, *Male Torso*

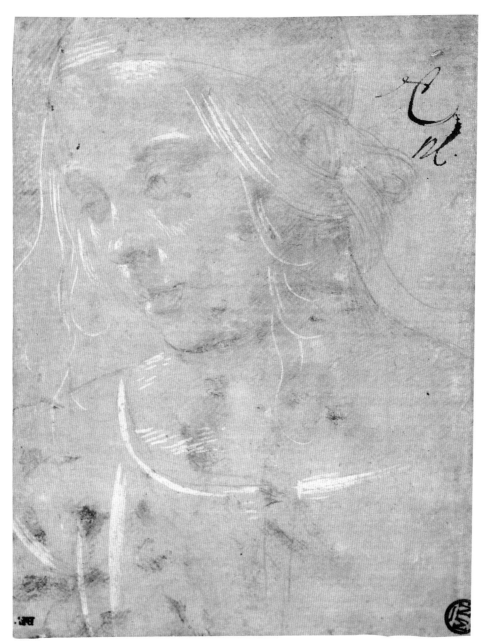

39. LORENZO DI CREDI, *Head of a Girl*

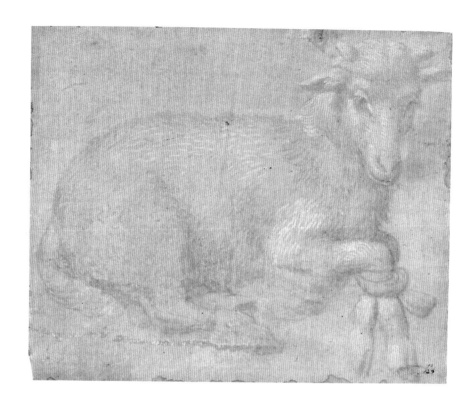

40. Lorenzo di Credi, *Lamb with its forelegs bound*

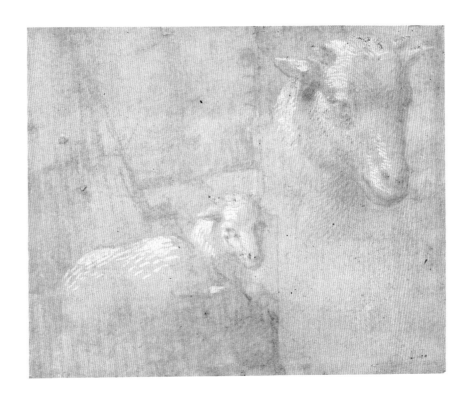

41. Lorenzo di Credi, *Lamb; Study of the head of the same animal*

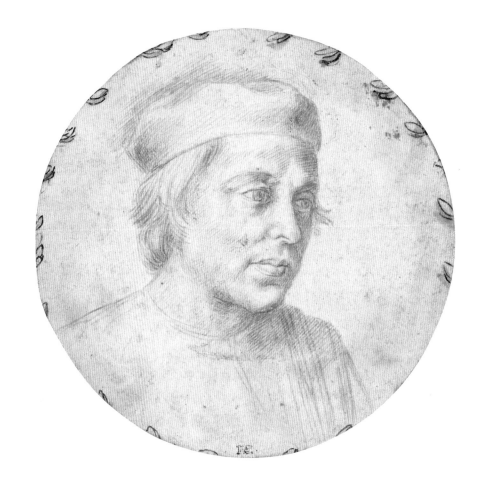

42. Lorenzo di Credi, *Man, half-length*

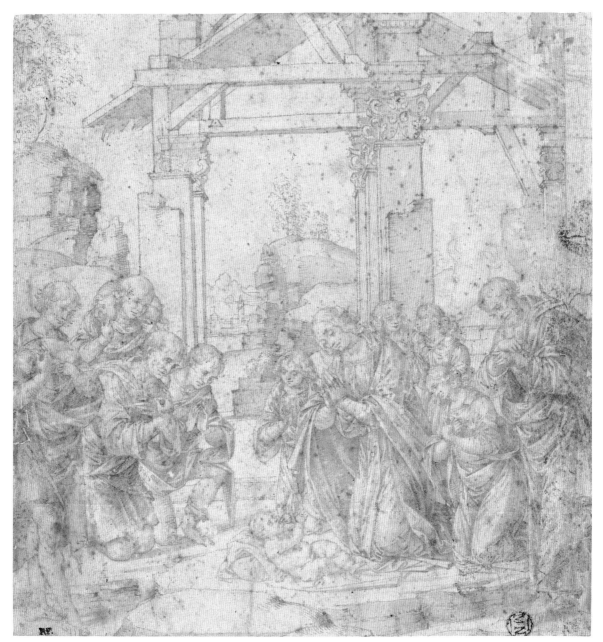

43. Lorenzo di Credi, *Adoration of the Shepherds*

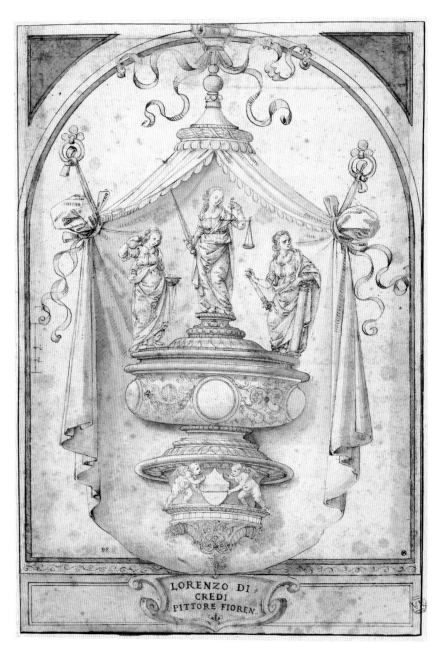

44. Lorenzo di Credi, *Sepulchral Monument*

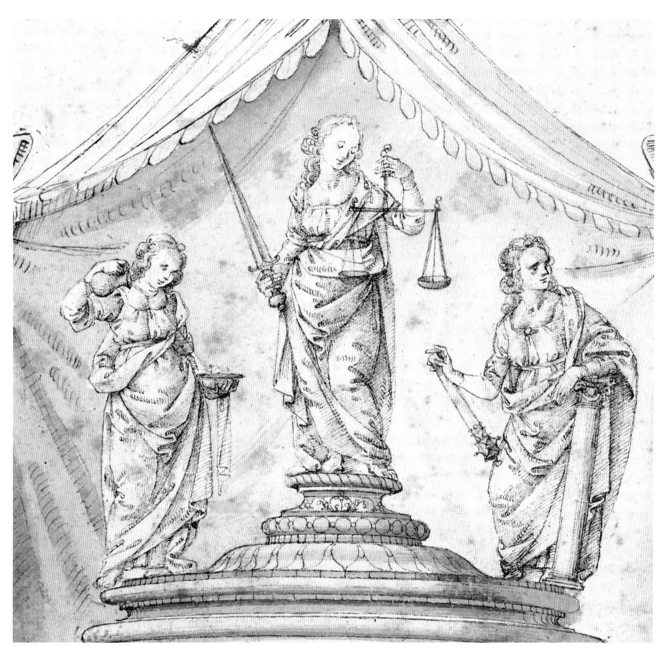

45. Lorenzo di Credi, Detail of Plate 44: *Cardinal Virtues*

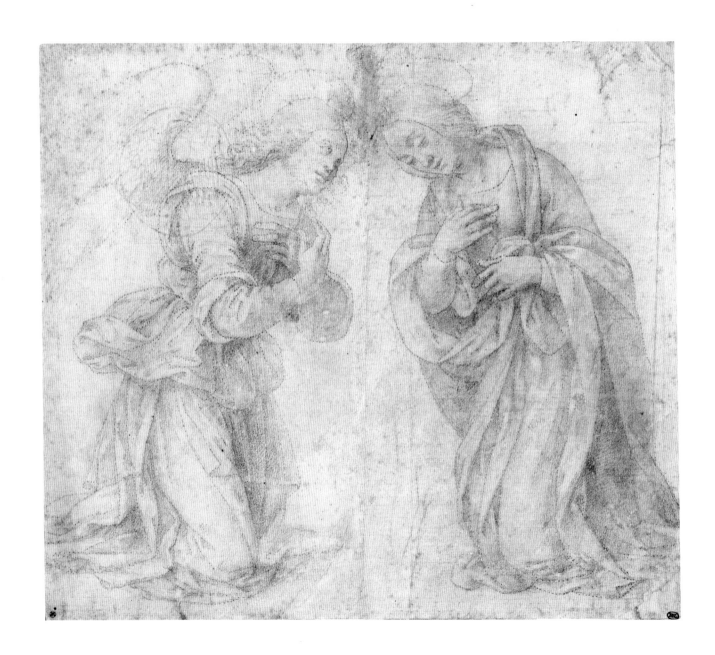

46. Lorenzo di Credi, *Annunciation*

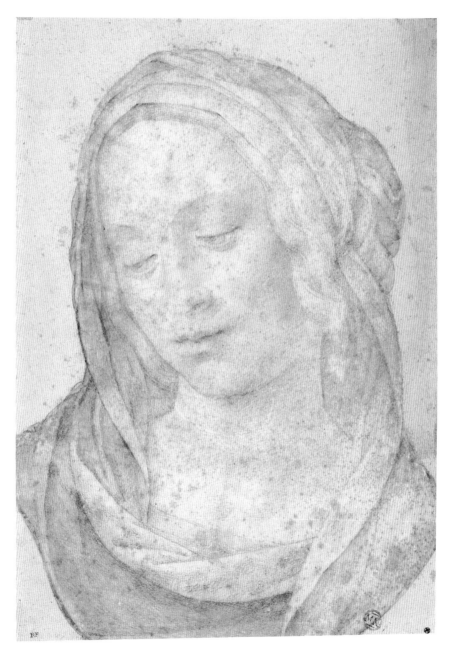

47. Lorenzo di Credi, *Female Head*

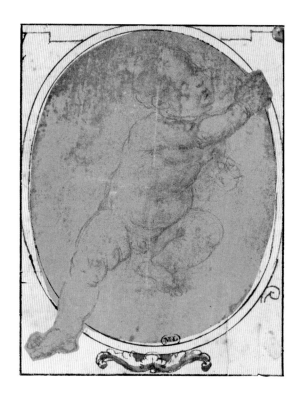

48. Circle of Lorenzo di Credi, *Nude Child*

49. Circle of LORENZO DI CREDI, *Nude Child*

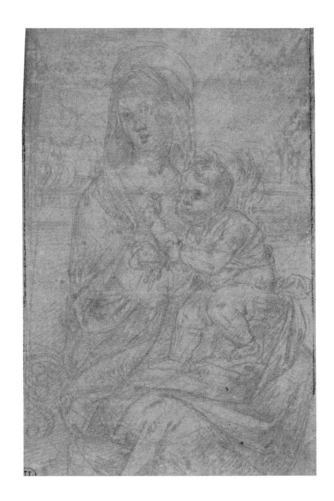

50. Circle of Lorenzo di Credi, *Madonna and Child*

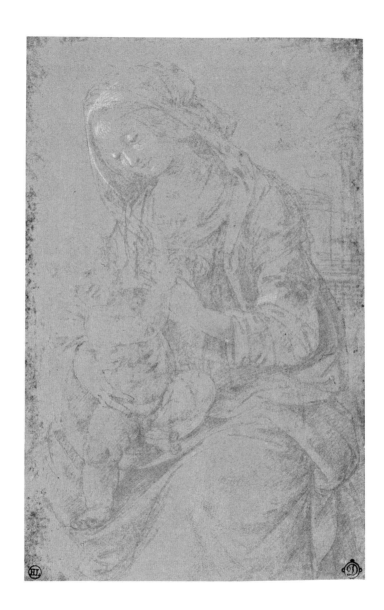

51. Circle of Lorenzo di Credi, *Madonna and Child*

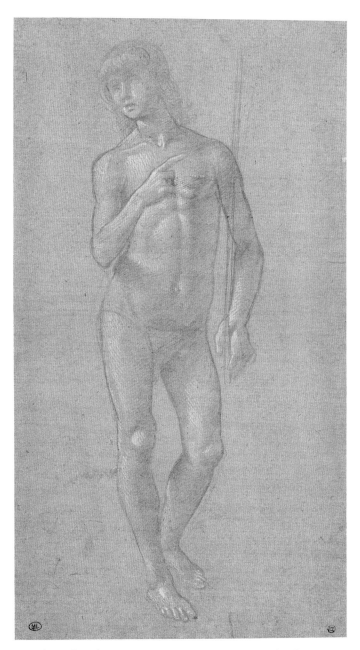

52. Traditional attribution to Lorenzo di Credi, *Saint John the Baptist* (?)

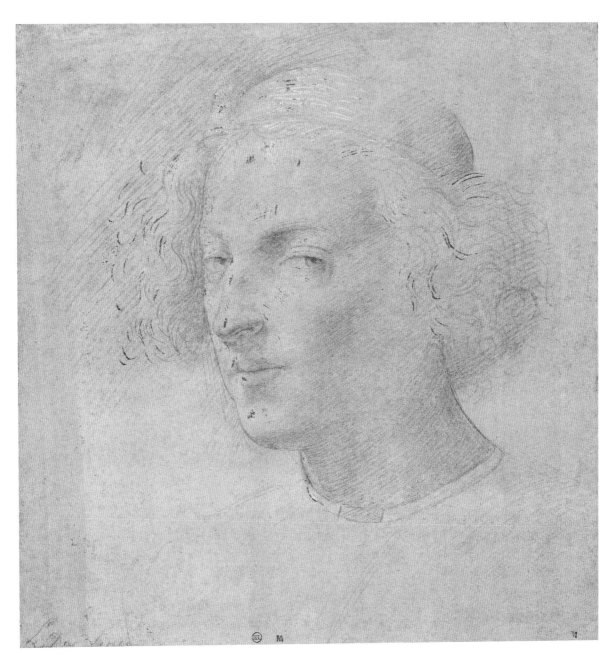

53. Traditional attribution to Lorenzo di Credi, *Head of a Youth*

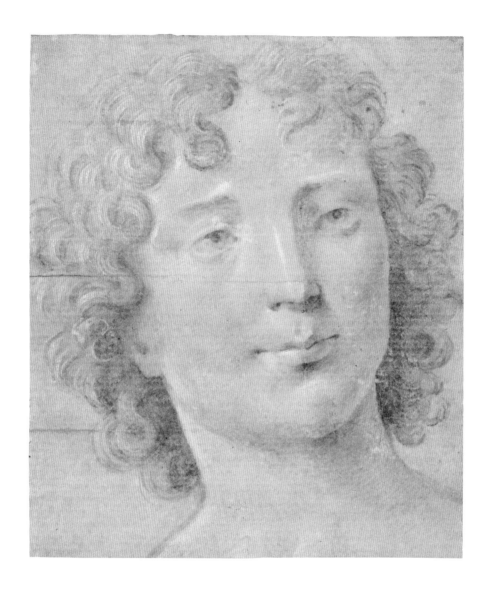

54. Traditional attribution to LORENZO DI CREDI, *Head of a Youth*

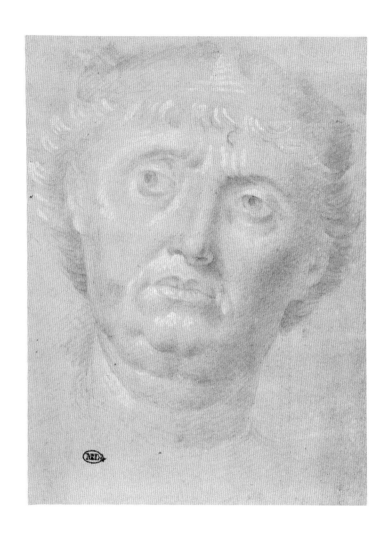

55. Traditional attribution to Lorenzo di Credi, *Male Head*

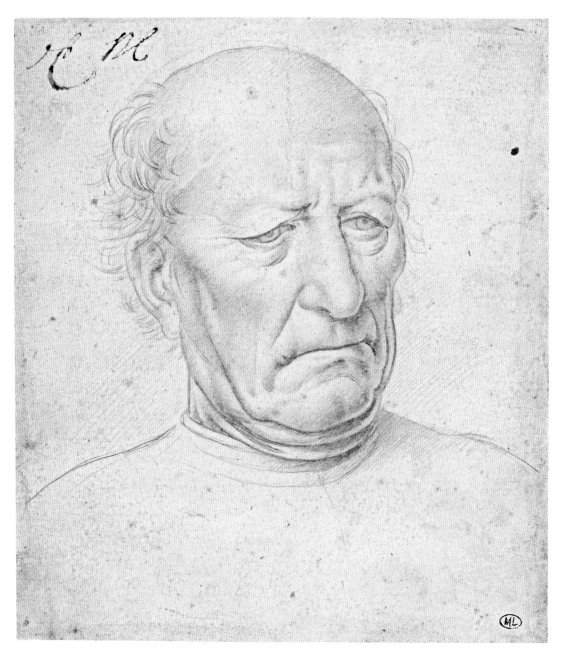

56. Traditional attribution to Lorenzo di Credi, *Head of an Elder*

CATALOGUE

Entries

by Laura Angelucci and Roberta Serra

Andrea del Verrocchio (or Leonardo da Vinci ?)

1. *Female Head, eyes lowered and slightly turned to the left*
Metalpoint, pen and black ink, grey ink, grey wash, white heightening, orange-red prepared paper. 26.8 × 22.3 cm.

Formerly catalogued in the Louvre among the anonymous sixteenth-century German drawings, this work was attributed to Verrocchio by Popp (1927), who identified it with one of the heads wrought by the artist that Vasari (1568) described. Suida (1929) ascribed it to Leonardo da Vinci and related it to the *Madonna with a Carnation* (Munich, Alte Pinakothek), whereas Goldscheider (1959) gave it to one of the artists in Verrocchio's workshop. It was later identified by Passavant (1969) as being the work of Lorenzo di Credi and by Brown (1998) with Perugino. Today, Dalli Regoli abides by Suida's opinion. However, the attribution of this sheet to Verrocchio is supported by comparisons with several of the artist's other works: the *Madonna and Child* in Berlin (Staatliche Museum); a bas-relief of the same subject in Florence (Museo Nazionale del Bargello); two studies of heads in London (British Museum, inv. 1895-9-15-785) and in Oxford (Christ Church Library, inv. 0005).
Provenance: G. Vasari, traces of mount on the verso – E. Jabach; drawing catalogued as "remainder" – Purchased for the Cabinet du Roi in 1671. Inv. 18965.

Andrea del Verrocchio

2. *Four* Putti; *Sketch of a Child's Head*
Pen and brown ink. Inscription in pen and brown ink, left lower section of sheet: *Viderunt equum mirandaque arte confectum / Quem nobiles veneti tibi dedere facturum / Florentiae decus crasse mihi crede Varochie / Qui te plus oculis amant dilliguntque coluntque / Atque cum Jupiter animas infuderit ipsi / Hoc tibi dominus rogat Salmonicus idem / Vale et bene qui legis.* 15.8 × 21 cm.

In the nineteenth century, His de la Salle (1795–1878) attributed the sheet to Verrocchio. The Latin verses, by an anonymous late fifteenth- or early sixteenth-century hand, are attributed to the statue of Colleoni (Venice) and confirms the attribution of the drawing to the master (Chennevières, 1879). The image of the child beside the inscription has an attitude analogous to that of the Christ Child appearing in two works most often attributed to Antonio Rossellino: the *Virgin and Child* on the relief in San Clemente at Sociana (Incisa in Val d'Arno, near Fiesole) and (reversed) on another carved element preserved in Vienna at the Kunsthistorisches Museum. Natali (1992) related the *putto* lying on its side, as well as the child in a like position on the verso, to similar figures drawn by Leonardo on sheets preserved in Venice (Gallerie dell'Accademia, inv. 256 and 259) and in Hamburg (Kunsthalle, inv. 21488).
Provenance: Richardson – Count Nils Bark – Count Thibaudeau – Purchased at the Wertheimer sale in 1871. Inv. RF 2 r°.

3. *Five* Putti
Pen and brown ink. 15. 8 × 21 cm.

The attribution of the sheet to Andrea del Verrocchio is due to His de la Salle. Berenson (1903) related the standing child, in the act of blessing, to the terra-cotta relief Verrocchio executed for Santa Maria Nuova in Florence (Museo Nazionale del Bargello). The same type of figures appears on several sheets, preserved in the Louvre, originating from the disassembled notebook, known as Verrocchio's sketchbook, that Morelli attributed to Francesco di

Simone in 1893 (pls. 11-15, 23). The child balancing on his right leg has been compared to the bronze *Putto with a Dolphin* in Florence (Palazzo della Signoria) and to another terra-cotta sculpture in Washington (National Gallery of Art). The *putto* lying on its side, like the child in the same position on the recto, is connected with figures drawn by Leonardo da Vinci on sheets preserved in Venice (Galleria dell'Accademia, inv. 256 and 259) and in Hamburg (Kunsthalle, inv. 21488).
Provenance: Richardson – Count Nils Bark – Count Thibaudeau – Purchased at the Wertheimer sale in 1871. Inv. RF 2 v°.

ANDREA DEL VERROCCHIO, School of

4. *Reliquary placed between a Bishop Saint and a Young Martyr on the left, and Saint John the Baptist and Saint Dominic on the right*
Pen and brown ink, brown wash. 21 × 19 cm.

His de la Salle gave this drawing to Andrea del Verrocchio with reservations, whereas BOTH DE TAUZIA (1881) attributed it to Desiderio da Settignano because of its likeness to the *Altare del Sacramento*, executed by that artist in San Lorenzo in Florence. KURZ (1955) confirmed this last attribution, identifying it as a study for the tabernacle placed over the altar, whereas AMES-LEWIS (1985) published the sheet under the name Francesco di Simone Ferrucci, because of its connection with the altar Carlo de' Medici commissioned to the artist in 1487 for the Pieve di Santo Stefano at Prato. According to the same author, two drawings, preserved in London (Victoria and Albert Museum, inv. E 1958–1924) and in Florence (Galleria degli Uffizi, inv. Horn 614), illustrate various stages of the execution of this carved work.
Provenance: A. Ch. H. His de la Salle – Gift in 1878. Inv. RF 454.

5. *Madonna and Child, half-length; Figures; Essays in writing*
Pen and brown ink, brown wash, black chalk tracing.
Design of letters in pen and brown ink: *P, R, M* (three, superimposed), *G* (two, superimposed), *O* (two), *A, H, N, P* (two, juxtaposed), *T* (two, juxtaposed). 20 × 19 cm.

This sheet, formerly identified by His de la Salle as an original by Andrea del Verrocchio, has been generally related to the artist's workshop since MÜNTZ (1899) proposed recognising Leonardo da Vinci's hand in the male figure, lower right; this artist's intervention on the sheet had also been upheld by RAVAISSON-MOLLIEN (1888), who attributed the inscriptions to Leonardo. According to POPHAM and POUNCEY (1950), this sheet is a page from the disassembled notebook known as Verrocchio's sketchbook, attributed to Francesco di Simone by MORELLI in 1893, several sheets of which are preserved in the Louvre (pls. 7-26). Instead, CADOGAN (1983; 2000) retained the attribution to Verrocchio; this was followed more recently by VIATTE (2003).
Provenance: A. Ch. H. His de la Salle – Gift in 1878. Inv. RF 453 r°.

6. *Study of interlacing between two balusters*
Pen and brown ink, brown wash. 15 × 8.4 cm.

This sheet, formerly identified by His de la Salle as an original by Andrea del Verrocchio, has been generally related to the artist's workshop since MÜNTZ (1899). According to POPHAM and POUNCEY (1950), this is a page from the disassembled notebook known as Verrocchio's sketchbook, attributed to Francesco di Simone by MORELLI in 1893, several sheets of which are preserved in the Louvre (pls. 7-26). Instead, CADOGAN (1983; 2000)

retained the former attribution to Verrocchio; this was followed more recently by VIATTE (2003). According to GALOPPINI (1988), this drawing is part of a group of "cellular structures in perspective" by Verrocchio's workshop, sheets distributed between Paris and Oxford (Christ Church Library, inv. 0042 and 0043).
Provenance: A. Ch. H. His de la Salle – Gift in 1878. Inv. RF 453 v°.

FRANCESCO DI SIMONE FERRUCCI

The Louvre has in their collection ten pages from a sketchbook that can be dated to the years 1485–1490, which were likely disassembled in France during the first half of the nineteenth century (pls. 7-26). The remaining leaves are now distributed between the École des Beaux-Arts in Paris, the Musée Condé in Chantilly, the Musée des Beaux-Arts in Dijon, the British Museum in London, the Kupferstichkabinett of Berlin, the Kunsthalle in Hamburg and the Metropolitan Museum of Art in New York. This ensemble, known for some time as Verrocchio's sketchbook, was attributed to Francesco di Simone by MORELLI in 1893. Since then, GRONAU (1896) and FABRICZY (1897) have both rejected the attribution of the group to Verrocchio, but without suggesting another name. Yet GRONAU maintained that Francesco di Simone must have been the author of the manuscript notes on the pages. Conversely, POPHAM and POUNCEY (1950), who upheld the attribution of the notebook to Francesco di Simone, proved that the identification of the writing with that of the artist could not be taken into account, since the contents of the inscriptions have nothing to do with the drawn motifs. Later, Ragghianti Collobi (1946 and 1954, quoted by LANFRANC DE PANTHOU, 1995), held the notebook to belong to the Siennese Francesco di Giorgio Martini during his Florentine period. Today, the attribution has been widely reverted to Francesco di Simone (AMES-LEWIS, 1981; LANFRANC DE PANTHOU, 1995; BAMBACH, 2003).

7. *The infant Jesus on the Madonna's lap; Flying Angel knocking over a vase; Essays in writing*
Pen and brown ink, metalpoint, watermarked paper. Watermark similar to Briquet 8348-8349, 8354. 27.5 × 19.1 cm.

Provenance: W. Mayor – Purchased at the sale of March 18th, 1856. Inv. 2241 r°.

8. *A Nude Man running; Three studies of a* Putto *balancing on one leg; Child working at an anvil; Standing Child, holding a shield*
Pen and brown ink, watermarked paper. Watermark comparable to Briquet 8348-8349, 8354. 27.5 × 19.1 cm.

The figure of the nude man running, upper left of the sheet, derives from one of the figures of the *Battle of Nude Men* engraved by Antonio Pollaiolo. The *putto* on the orb toward the centre, like the one outlined in the upper right, corresponds to other studies by Francesco di Simone on the Louvre sheets (pls. 13 and 15). LANFRANC DE PANTHOU (1995) observed that the standing child, with one hand resting on its hip and holding a shield in the other (lower half of the sheet, centre), was replicated by the artist in other drawings preserved in the Louvre (pls. 19 and 21), at the École des Beaux-Arts in Paris (inv. 373 v°) and at Chantilly (Musée Condé, inv. 21[15] r°).
Provenance: W. Mayor – Purchased at the sale of March 18th, 1856. Inv. 2241 v°.

9. *Resurrection of Christ; Angel; Nude Child running toward the left*
Pen and brown ink, metalpoint, watermarked paper partially washed in pink. Watermark comparable to Briquet 8348-8349, 8354. 27.7 × 19.6 cm.

Provenance: W. Mayor – Purchased under the reign of Napoleon III. Inv. 2242 r°.

10. *Two studies for an infant Saint John, and correction of his left arm; Young Man, half-length; Child, half-length; Several pen essays*
Pen and brown ink, metalpoint, watermarked paper. Watermark similar to Briquet 8348-8349, 8354. 27.7 × 19.6 cm.

The infant Saint John the Baptist, appearing upper left of the sheet, is apparently a variant of a study on plate 11.
Provenance: W. Mayor. Inv. 2242 v°.

11. *Cupid; The infant Saint John; Putto; Two studies of the Christ Child blessing; Two studies of a Young Man-of-Arms; Nude Man running; Profile of a Youth, half-length*
Pen and brown ink, metalpoint, watermarked paper. Watermark similar to Briquet 8348-8349, 8354. 26.2 × 19.4 cm.

Several of the motifs drawn on this sheet can be seen on other pages of Francesco di Simone's sketchbook in the Louvre: the Christ Child blessing appears on the verso of this same sheet, as well as on plates 13-15 and 23; the infant Saint John seems to be a variant of a study drawn on the sheet, plate 10.
Provenance: W. Mayor – Purchased under the reign of Napoleon III. Inv. 2243 r°.

12. *Two Children; Madonna and Child; A standing Monk*
Pen and brown ink, metalpoint, watermarked paper. Watermark similar to Briquet 8348-8349, 8354. 26.2 × 19.4 cm.

The Madonna and Child, lower right, shows the same detail as that of a group appearing on plate 13. For the Christ Child blessing, see the above entry for plate 11.
Provenance: W. Mayor – Purchased under the reign of Napoleon III. Inv.. 2243 v°.

13. Putto *on a dolphin; Five studies of the Christ Child; Madonna and Child*
Pen and brown ink, brown wash. Traces of metalpoint. 27 × 19 cm

Wright (WRIGHT and RUBIN 1999) pointed out the connection between the child balancing on the dolphin's head, upper left of the page, and the bronze sculpture that Verrocchio executed in 1470 (Florence, Palazzo della Signoria, Quartiere degli Elementi); similar figures are sketched on other Louvre sheets (pls. 8 and 15). As regards the four drawings for the Christ Child blessing, these are similar to studies on three other sheets by Francesco di Simone, also in the Louvre (pls. 11-12, 14-15). The Madonna and Child group, lower right, is clearly related to other studies on the two pages from the same sketchbook (pl. 12); Chantilly, Musée Condé, inv. 22[16] r°.
Provenance: A. - Ch.-H. His de la Salle – donation to the Louvre in 1878. Inv. RF 446 r°.

14. *Male Head in profile; Hercules with two corrections of his right leg; Four studies of the Christ Child*
Pen and brown ink, traces of metalpoint. 27 × 19 cm.

Next to a copy after the drawing of *Hercules and the Lernaean Hydra*

by Antonio Pollaiolo (London, British Museum, inv. 5210-8 r°), a preparatory for the lost painting of the Palazzo Medici in Florence, this page of the sketchbook shows three studies of Children that can be likely related to similar motifs drawn on other sheets attributed to Francesco di Simone in the Louvre (pls. 11-13, 15).
Provenance: A. -Ch. H. His de la Salle – donation to the Louvre in 1878. Inv. RF 446 v°.

15. *Putto balancing on an orb; Four studies of the Christ Child*
Pen and brown ink, metalpoint, watermarked paper. Watermark similar to Briquet 8348-8349, 8354. 26.6 × 18.8 cm.

GRONAU (1896), who did not accept the attribution of Verrocchio's sketchbook to Francesco di Simone, preferring to ascribe it to an anonymous artist, identified the Christ Child blessing, (centre of sheet) as a study for the Tabernacle of the Holy Oil in the church of Santa Maria di Monteluce, at Perugia (1487). FABRICZY (1897) also connected it with this carved work, but held that the drawing was a copy of it. Among the other motifs on the sheet, several can be found again on other pages of the same notebook in the Louvre: the Christ Child blessing on plates 11-14; the *putto* balancing on the orb relates to the studies on plates 8 and 13.
Provenance: A. -Ch. -H. His de la Salle – donation to the Louvre in 1878. Inv. RF 447 r°.

16. *Relief of a Sarcophagus with two* Putti *bearing a wreath; Man with classical drapery; Two studies of a standing Child; Scene with three Men; Christ in bonds; Man partially draped striding; Youth praying*
Pen and brown ink, metalpoint, watermarked paper partially washed in pink. Watermark similar to Briquet 8348-8349, 8354. 26.6 × 18.8 cm.

The sketch of the draped man, appearing in the upper left, can be related to the *Study of Saint John the Baptist* drawn on a sheet preserved at Chantilly (Musée Condé, inv. 20[14] r°). As Cordellier pointed out (note in drawing folder, 1992), the figure slightly straining forward, with arms behind its back, lower left, was drawn after a model whom Raphael was also to draw later (Vienna, Graphische Sammlung Albertina, inv. 195 v°). According to KWAKKELSTEIN (2002), Raphael would have been

familiar with it through Francesco di Simone's drawing. Dalli Regoli suggests that the two drawings had a common source in a bronze bas-relief executed by Francesco di Giorgio Martini at Perugia circa 1480–1485, representing a *Flagellation* (Perugia, Galleria Nazionale dell'Umbria). The same attitude can be observed in Sodoma's *Saint Sebastian* (Florence, Galleria degli Uffizi).
Provenance: A. -Ch. -H. His de la Salle – donation to the Louvre in 1878. Inv. RF 447 v°.

17. *Three studies of Arms; Leg of a Child; Three studies of a Coronation of the Virgin (?); A Face in profile; Four studies for two Saints*
Pen and brown ink, brown wash, paper partially washed in pink. 25.6 × 18.6 cm.

LANFRANC DE PANTHOU (1995) draws attention to a motif similar to that of the arm holding a cloth (upper margin), on a sheet preserved at Chantilly (Musée Condé, 22[16] v°). PEDRETTI (1998) attributed the essays written in pen and brown ink (upper left), to Leonardo da Vinci. The face in profile also seems somewhat reminiscent of Leonardo's work.
Provenance: A. -Ch. -H. His de la Salle – donation to the Louvre in 1878. Inv. RF 448 r°.

18. *Study of a Child holding a banderole; Sketch of a Candelabra; Harpy*
Pen and brown ink, metalpoint, paper partially washed in pink. 25.6 × 18.6 cm.

Provenance: A. -Ch. -H. His de la Salle – donation to the Louvre in 1878. Inv. RF 448 v°.

19. Putto *holding a shield; A Cherub musician and others upholding a banderole; Youth in conversation with a Hunter; Two saints Jerome*
Pen and brown ink, metalpoint, watermarked paper partially washed in pink. Watermark similar to Briquet 8348-8349, 8354. 27 × 19 cm.

The motif of the standing *putto* holding a shield in one hand

(upper left) was studied several times by Francesco di Simone (pls. 8 and 21; Paris, École Nationale Supérieure des Beaux-Arts, inv. 373 v°; Chantilly, Musée Condé, inv. 21[15] r°). The two studies of *putti* holding a cartouche (lower right), are perhaps preparatory for those of the *Tomb of Barbara Manfredi*, executed by the artist after 1466, in the abbey of San Mercuriale, at Forlì. The standing Saint Jerome (lower left), is comparable to a *Study for a Saint John the Baptist* drawn on a Chantilly sheet (Musée Condé, inv. 20[14] r°).
Provenance: A. -Ch. -H. His de la Salle – donation to the Louvre in 1878. Inv. RF 449 r°.

20. Putti *musicians; Saint John the Baptist; Sea Centaur carrying off a Nymph; Four studies for the young Saint John the Baptist; Caricature profile*
Pen and brown ink, metalpoint, brown wash, watermarked paper partially washed in pink. Watermark similar to Briquet 8348-8349, 8354. 27 × 19 cm.

According to KURZ (1955), the Saint John the Baptist is a copy drawn by Francesco di Simone, after similar figures appearing on two studies for sculpted altars, attributed to his pupil Andrea di Piero Ferrucci (1465-1526), now preserved in London (Victoria and Albert Museum, inv. 4904 and inv. E. 1958-1924).
Provenance: A. -Ch. -H. His de la Salle – donation to the Louvre in 1878. Inv. RF 449 v°.

21. *Head and arm of a Child; Two studies for a* Putto *holding a shield, standing on an entablature*
Pen and brown ink, brown wash, metalpoint, paper partially washed in pink. 23 × 18.5 cm

The standing *putto*, one hand resting on its hip and holding a shield in the other, was studied several times by the artist (pls. 8 and 19; Paris, École Nationale Supérieure des Beaux-Arts, inv. 373 v°; Chantilly, Musée Condé, inv. 21[15] r°).
Provenance: A. -Ch. -H. His de la Salle – donation to the Louvre in 1878. Inv. RF 450 r°.

22. *Three studies of Apollo (?); Three Heads in profile after antique medals; Two studies of an Ear; Nude Child, seated*

Pen and brown ink, metalpoint (silver?), paper washed in pink. 23 × 18.5 cm.

The two heads in profile (left) are copies after antique medals that relate to those on two other sheets by Francesco di Simone, preserved in London (British Museum, inv. 1975-6-12-16 r°) and in Chantilly (Musée Condé, inv. 21[15] v°). In the right half of the sheet, the two figures of nude youths are replicas of the Apollo in the *Medici Cameo* (Naples, Museo Archeologico Nazionale), a cornelian now attributed to Dioscurides, on which the god is represented with Marsyas. The same figure can be seen on another sheet by the artist, preserved in London (British Museum, inv. 1952-4-5-1).
Provenance: A. -Ch. -H. His de la Salle – donation to the Louvre in 1878. Inv. RF 450 v°.

23. *Nude Youth, standing; Christ Child blessing; Head leaning to the left*
Pen and brown ink, brown wash, metalpoint, paper washed in pink. 26 × 19 cm.

The study of a nude youth (center) recalls Andrea del Verrocchio's *David* (Florence, Museo Nazionale del Bargello). A similar drawing by Lorenzo di Credi is preserved at Oxford (Christ Church Library, inv. 0057)
Provenance: A. -Ch. -H. His de la Salle – donation to the Louvre in 1878. Inv. RF 45I r°.

24. *Nude Child, seated; Standing Man, holding a sword; Headless male Nude*
Pen and brown ink, metalpoint, paper washed in pink. 26 × 19 cm.

The seated child can be seen on other pages of studies by Francesco di Simone, preserved in London (British Museum, inv. 1875-6-12-16 v°) and at Chantilly (Musée Condé, inv. 21[15] r°).
Provenance: A. -Ch. -H. His de la Salle – donation to the Louvre in 1878. Inv. RF 451 v°.

25. *Coat-of-Arms with six mounts and a river, upheld by a crouching lion with its tail between its paws, wearing a helmet with an eagle (?) on the crest; Madonna and Child with Saint John (?); Correction of a Child's leg; Outline of a Horse*
Pen and brown ink, metalpoint, brown wash, watermarked paper partially washed in pink. Watermark similar to Briquet 8348-8349, 8354. 27 × 17.8 cm.
Provenance: A. -Ch. -H. His de la Salle – donation to the Louvre in 1878. Inv. RF 452 r°.

26. *Studies for the Martyrdom of Saint Sebastian*
Pen and brown ink, metalpoint, paper washed in pink. 27 × 17.8 cm.

Provenance: A. -Ch. -H. His de la Salle – donation to the Louvre in 1878. Inv. RF 452 v°.

LORENZO DI CREDI

27. *Man, half-length, wearing a cap*
Metalpoint (silver?), white heightening, pink prepared paper. 21.5 × 17 cm.

DEGENHART (1931) related this drawing to a sheet preserved at Windsor (Royal Library, 12817), previously pointed out by BERENSON (1903) as being by Lorenzo di Credi, but which according to Degenhart might be a copy by his workshop. DALLI REGOLI (1966) suggested considering it an autograph study for the head of Saint Donatus of the *Sacra Conversazione* by Andrea del Verrocchio and his collaborators, in the Cathedral of Pistoia. DEGENHART (1931) and later VERTOVA (1976) saw in it a portrait taken from life, executed toward the end of the year 1490. This drawing is connected with another in Edinburgh (National Gallery of Scotland, D 642 v°).
Provenance: E. Jabach, drawing catalogued as "remainder" – Purchased for the Cabinet du Roi in 1671. Inv. 1785. DALLI REGOLI 1966, n. 22.

28. *Saint John the Baptist, standing*
Silverpoint, brown wash, white heightening, pink prepared paper. 27.5 × 13 cm.

Prior to 1775, Mariette attributed this drawing to Giovanni Bellini, and His de la Salle to either Lorenzo di Credi or Andrea del Verrocchio. EPHRUSSI (1882) identified it as a study for the Saint John the Baptist of the altarpiece of the Pistoia Cathedral with the *Madonna and Child* enthroned between *Saint John the Baptist* and

Saint Donatus (Madonna di Piazza, completed after 1485; also known as the *Sacra Conversazione*). It appears to have been drawn after a live model (BAMBACH, 2003). CHIAPPELLI (1925–1926) recognised in it Andrea del Verrocchio's hand, whereas DEGENHART (1932), followed by CHASTEL (1950; 1955), saw in it a work in which that artist collaborated with Lorenzo. It can be related to a study by Leonardo da Vinci at Windsor (The Royal Library, inv. 12572).
Provenance: G. Vasari – E. Jabach – P. J. Mariette (L 2097) – Count Moriz von Fries – Count N. Barck – A. -Ch. -H. His de la Salle – Gift in 1878. Inv. RF 455. DALLI REGOLI, 1966, n. 13.

29. *Study of drapery for the figure of Saint Bartholomew*
Brush and grey gouache, white heightening, outlines in black chalk, red chalk and white gouache completed with a brush with pigments and oil, yellow-brown prepared paper. 38.9 × 27 cm.

Filippo Baldinucci had already attributed this drawing to Lorenzo di Credi in the seventeenth century, identifying it as a study for the drapery of *Saint Bartholomew*, painted probably circa 1490–1495 (definitely before 1510), in the church of Orsanmichele, in Florence (east wall). According to DALLI REGOLI (1966), the arrangement and the structure of the drapery relate instead to the *Young Saint in Glory* of Pasadena (S. Marino, Huntington Art Gallery). The drawing is connected with other studies of drapery preserved at Chantilly (Musée Condé, inv. 34), Rennes (Musée des Beaux-Arts, inv. 794. 1. 2507) and Turin (Biblioteca Reale, 16158).
Provenance: F. Baldinucci – F. S. Baldinucci – P. Pandolfini, C. Pandolfini, R. Pandolfini, A. Pandolfini, A. E. Pandolfini and E. T. Pandolfini, by legacy – Sold through F. Strozzi to the Musée Napoléon in 1806. Inv. 1791. DALLI REGOLI, 1966, n. 17.

30. *Female Head, three-quarter view*
Metalpoint (silver?), white heightening, pink prepared paper. 29.5 × 21 cm.

For BERENSON (1903), this drawing is likely a study for the *Venus* of the Galleria degli Uffizi, in Florence. It is pasted on a fragment of Giorgio Vasari's *Libro dei disegni*, which still bears the cartouche with the artist's name.
Provenance: G. Vasari – P. -J. Mariette – Purchased for the Cabinet du Roi in 1775. Inv. 1783. DALLI REGOLI, 1966, n. 58.

31. *Head of a Youth, wearing a skull-cap*
Metalpoint (silver?), white heightening, pale pink prepared paper. 24.5 × 18.8 cm.

According to BERENSON (1903), this study was executed after the same model as that of a drawing in London (British Museum, inv. 1895-9-15-462) and as that of Pietro Perugino's *Portrait of a Youth* preserved in Florence (Galleria degli Uffizi).
Provenance: P. -J. Mariette – Purchased for the Cabinet du Roi in 1775. Inv. 1782. DALLI REGOLI, 1966, n. 114.

32. *Head of a Youth, looking downward*
Metalpoint (silver?), white heightening, watermarked pink prepared paper, watermark similar to Briquet 11678-11728. 17.5 × 14.5 cm.

Formerly catalogued among the anonymous fifteenth-century Florentines, this drawing was given back to Lorenzo di Credi by BERENSON (1903). In another Louvre drawing, also on pink prepared paper, the artist represented the same model, the head bent forward and the face foreshortened (pl. 33).
Provenance: E. Jabach, drawing catalogued as "remainder" – Purchased for the Cabinet du Roi in 1775. Inv. 2675. DALLI REGOLI, 1966, n. 46.

33. *Head of a Youth, three-quarter view, bent forward*
Silverpoint, white heightening, pink prepared paper. 14.3 × 12.9 cm.

Baldinucci attributed this drawing to Antonio Pollaiolo. Later, REISET (1866) catalogued it among the anonymous fifteenth-century Florentines. BERENSON (1903) gave it back to Lorenzo di Credi, relating it to another drawing by the artist preserved in the Louvre, executed after the same model (pl. 32).
Provenance: F. Baldinucci – F. S. Baldinucci – P. Pandolfini, C. Pandolfini, R. Pandolfini, A. Pandolfini, A. E. Pandolfini and E. T. Pandolfini, by legacy – Sold through F. Strozzi to the Musée Napoléon in 1806. Inv. 2576. DALLI REGOLI, 1996, n. 47.

34. *Head of a Youth, full-face view, looking upward*
Metalpoint (silver?), white heightening, salmon-pink prepared paper. 24.2 × 18.6 cm.

Prior to 1775, Mariette had attributed this drawing to Lorenzo di Credi. BERENSON (1903) recognised in it the same model as the one represented on a sheet of the Christ Church Library at Oxford (inv. B 7). It has also been related to a study in the British Museum in London (inv. 1895-9-15-460). The drawing on the verso (not illustrated), in a technique unusual for Lorenzo's work, was rightly barred from the artist's catalogue by BERENSON (1938), Bacou (POUNCEY and BACOU, 1952) and DALLI REGOLI (1966).
Provenance: P. -J. Mariette – Purchased for the Cabinet du Roi in 1775. Inv. 1781 r°. DALLI REGOLI, 1966, n. 57.

35. *Head of an elderly Man, full-face view, wearing a cap*
Metalpoint (silver?), white heightening, pink prepared paper.
29.5 × 21 cm.

This drawing, attributed to Lorenzo di Credi by Mariette prior to 1775, can be related to another study of a head preserved in London (British Museum, inv. 1459-1537), which was clearly drawn from life. BERENSON (1903) saw in it a recollection of Pietro Perugino's work.
Provenance: P. -J. Mariette – Purchased for the Cabinet du Roi in 1775. Inv. 1779. DALLI REGOLI, 1966, n. 133.

36. *Head of an Elder*
Metalpoint (silver?), white heightening, grey prepared paper.
13 × 10.5 cm.

This drawing belongs to a group of six sheets (pls. 40-42, 54 and inv. 1784B, not illustrated), whose treatment is not homogeneous. They are assembled in the same mount and bear an attribution to Lorenzo di Credi, given by Mariette prior to 1775.
Provenance: P. -J. Mariette – Saint-Morys – Confiscation of the property of the Émigrés in 1793, entrusted to the Museum in 1796-1797. Inv. 1784E. DALLI REGOLI, 1966, n. 134.

37. *Male Head, three-quarter view, bent toward the left*
Metalpoint (silver?), white heightening, pink prepared paper.
21.5 × 17.5 cm.

Attributed to Lorenzo di Credi by Mariette prior to 1775, this drawing was believed by BERENSON (1903; 1938) to be a study for the Saint Joseph in the *Adoration of the Shepherds* executed for the church of Santa Chiara, in Florence (Uffizi). It was later (1961) considered a drawing for the Saint Nicholas of the *Madonna between Saint Julien and Saint Nicholas*, placed in 1493 in the cappella Mascalzoni at Santa Maria de' Pazzi, in Florence (Louvre).
Provenance: P. -J. Mariette – Purchased for the Cabinet du Roi in 1775. Inv. 1780. DALLI REGOLI, 1966, n. 91.

38. *Male Torso, half-nude*
Metalpoint (silver?), white heightening, pink prepared paper.
20.3 × 14.6 cm.

Formerly, Filippo Baldinucci gave this study to Antonio Pollaiolo, and REISET (1866) to a fifteenth-century Florentine artist. BERENSON (1938) attributed it to Francesco Granacci, but DEGENHART (1932) gave it back to Lorenzo di Credi. DALLI REGOLI (1966) confirmed the attribution of the sheet to Lorenzo di Credi, and saw it as a study for the figure of a crucifixion (or a martyr), similar to research carried out by the artist for the thief in the *bozzetto* of the *Crucifixion* (right side) preserved at Göttingen (Kunstsammlung der Universität), which was painted in the late fifteenth century. This same author, owing to the morphological correspondence of the torso with that of the Saint Sebastian of the Malatesta altarpiece wrought by Domenico Ghirlandaio and collaborators (Rimini, Museo), has suggested identifying this drawing as a project by Lorenzo di Credi, used with variants by Fra Bartolomeo to complete the painting.
Provenance: F. Baldinucci – F. S. Baldinucci – P. Pandolfini, C. Pandolfini, R. Pandolfini, A. Pandolfini, A. E. Pandolfini and E. T. Pandolfini, by legacy – Sold through F. Strozzi to the Musée Napoléon in 1806. Inv. 2677. DALLI REGOLI, 1996, n. 149.

39. *Head of a young Girl, three-quarter view, leaning to the left*
Metalpoint (silver?), white heightening, beige prepared paper.
19 × 13 cm.

A drawing, on the verso, representing a *Male Head, left profile*, can be seen in transparency.
Provenance: E. Jabach, drawing catalogued as "remainder" – Purchased for the Cabinet du Roi in 1671. Inv. 1786 r°. DALLI REGOLI, 1966, n. 88.

40. *Study of a Lamb, its forelegs bound*
Metalpoint (silver?), grey wash, white heightening, pale beige prepared paper. 9 × 11 cm.

This and the following drawing belong to a group of six sheets (pls. 36, 40-42, 54 and inv. 1784B, not illustrated), whose treatment is not homogeneous. They are assembled in the same mount and bear an attribution to Lorenzo di Credi assigned by. Mariette prior to 1775, before his collection was dispersed. They are comparable to a study of a lamb preserved in Florence (Galleria degli Uffizi, inv. Horn 789). DALLI REGOLI, who earlier pointed out (1966) that their state of conservation did not allow them to be identified as autograph drawings or workshop products (perhaps done by Giovanni Antonio Sogliani), has now confirmed the originality of these works. She dates these works to Lorenzo di Credi's late production.
Provenance: P. -J. Mariette – Saint-Morys – Confiscation of the property of the Émigrés in 1793, entrusted to the Museum in 1796–1797. Inv. 1784. DALLI REGOLI, 1966, n. 93.

41. *Study of a Lamb; Study of the Head of the same animal*
Metalpoint (silver?), grey wash, white heightening, pale beige prepared paper, on two leaves pasted together. Traces of red chalk. 9 × 11 cm.

See plate 40.
Inv. 1784A. DALLI REGOLI, 1966, n. 94.

42. *Man, half-length, wearing a skull-cap, three-quarter view to the right*
Metalpoint (silver?), grey prepared paper. Round form. Diameter: 11.7 cm.

This drawing, like the two preceding ones, belongs to a group of six sheets (pls. 36, 40-42, 54 and inv. 1784B, not illustrated), whose treatment is not homogeneous. They are assembled in the same mount and bear an attribution to Lorenzo di Credi assigned by Mariette prior to 1775.
Provenance: P. -J. Mariette – Saint-Morys – Confiscation of the property of the Émigrés in 1793, entrusted to the Museum in 1796–1797. Inv. 1784C.

43. *Adoration of the Shepherds*
Pen and brown ink, brown wash, white heightening.

Traces of black chalk. Pricked for transfer. 22 × 21 cm.

In the seventeenth century Jabach attributed this drawing to Raphael. BOTH DE TAUZIA (1888) gave it to Lorenzo di Credi. DEGENHART (1932) ascribed it to Giovanjacopo Castrocaro, a pupil of the artist. According to DALLI REGOLI (1966), it is likely a study for the *Adoration of the Shepherds* executed for the church of Santa Chiara in Florence (Uffizi); it could also be a later replica of the subject for a work by Lorenzo di Credi or one of his pupils. A copy of the right section of the sheet is preserved in Florence, Galleria degli Uffizi, inv. 14518F.
Provenance: E. Jabach, presentation drawing – Purchased for the Cabinet du Roi in 1671. Inv. 1790. DALLI REGOLI, 1966, n. 148.

44. *Project for a sepulchral Monument*
Pen and brown ink, brown wash. Traces of black chalk. 29.6 × 21.9 cm.

Attributed to Lorenzo di Credi by Vasari, this drawing is the variant of a study for a tomb preserved in London (Victoria and Albert Museum, inv. 2314). The attribution of the sheet is disputed: DEGENHART (1932) saw in it a study for a triumphal float assigned to Gianjacopo Castrocaro, Lorenzo's pupil; for MÖLLER (1935), it may be by one of Verrocchio's collaborators whose name is unknown; Pouncey (POUNCEY and BACOU, 1952) gives it to Lorenzo di Credi's workshop, and VERTOVA (1976) to Verrocchio's. However, DALLI REGOLI (1965; 1966), and more recently NATALI (1992), confirm that the drawing is an autograph.
Provenance: G. Vasari – P. -J. Mariette – Purchased for the Cabinet du Roi in 1775. Inv. 1788. DALLI REGOLI, 1966, n. 137.

45. Detail of plate 44: *Cardinal Virtues*

46. *Studies for an Annunciation*
Black chalk, on two joined pieces of paper. Transfer pricks. 26 × 29.6 cm.

In the middle of the eighteenth century, Mariette joined the two studies for an *Annunciation* under Lorenzo di Credi's name. BERENSON (1938), also relating them to the same artist, dated them to the artist's mature years. This work may be a cartoon for

a small painting or for an embroidery (POUNCEY and BACOU, 1952). DALLI REGOLI (1966) published them among the sheets drawn by Lorenzo di Credi in collaboration with Giovanni Antonio Sogliani.
Provenance: P. -J. Mariette – Saint-Morys – Confiscation of the property of the Émigrés in 1793, entrusted to the Museum in 1796–1797. Inv. 1789. DALLI REGOLI, 1966, n. 161.

47. *Head of a Woman, wearing a veil*
Red chalk, white heightening. Cut out along the silhouette of the figure and pasted on another sheet. 29.2 × 21.5 cm.

BERENSON (1903) identified this drawing, attributed to Lorenzo di Credi since the eighteenth century, as a study for the Madonna of the *Sacra Conversazione* painted for the Compagnia di San Bastiano in Florence (ca. 1516) and preserved today in Dresden (Staatliche Kunstsammlungen, inv. 5). DALLI REGOLI (1966) saw in it Giovanni Antonio Sogliani's hand and related it to the *Sacra Conversazione*, executed for the Ospedale del Ceppo at Pistoia (Museo Civico).
Provenance: P. -J. Mariette – Purchased for the Cabinet du Roi in 1775. Inv. 1787. DALLI REGOLI, 1966, n. 165.

LORENZO DI CREDI, Circle of

48. *Nude Child, seated, right leg outstretched*
Metalpoint (silver?), salmon-pink prepared paper. 8.5 × 7 cm.
Ovoid form.

This drawing and the next two were joined formerly in the same mount and owned by a late sixteenth- early seventeenth-century collector, according to DALLI REGOLI (1966), or to VASARI, as RAGGHIANTI COLLOBI (1974) points out. In this case, these drawings would be fragments of a page from his *Libro dei disegni*. Their attribution to Lorenzo di Credi is due to REISET (1866), who added, however that: "We could just as well give them to Andrea del Verrocchio, Lorenzo di Credi's master". While DEGENHART (1932) preferred giving them to the artist's school, DALLI REGOLI (1966) suggested an attribution to Lorenzo himself. She relates the two studies of a *putto* to a drawing at Darmstadt (Hessisches, Landesmuseum, inv. 57) and the *Madonna and Child* to three drawings preserved in the Louvre

(inv. RF 463), at Darmstadt (Hessisches Landesmuseum, inv. 131) and at Cleveland (Cleveland Museum of Art). For BAMBACH (1999), the studies of children belong to a group of drawings derived from the Child in Leonardo da Vinci's *Madonna with a Carnation*, (now in Munich; Alte Pinakothek), distributed between Florence (Galleria degli Uffizi, inv. 476E and 1197E) and Bayonne (Musée Bonnat, inv. 1236). Today, there is the temptation to return the attribution to a member of Lorenzo di Credi's circle. This drawing was done by the same hand as the work in plate 51 (inv. RF 463).
Provenance: G. Vasari – Saint-Morys – Confiscation of the property of the Émigrés in 1793, entrusted to the Museum in 1796–1797. Inv. 1792 ter. DALLI REGOLI, 1966, n. 7.

49. *Nude Child, seated, facing left*
Metalpoint (silver?), salmon-pink prepared paper. 8.8 × 7 cm.
Ovoid form.

See plate 48.
Inv. 1792. DALLI REGOLI, 1966, n. 7.

50. *Madonna and Child*
Metalpoint (silver?), salmon-pink prepared paper. 11.6 × 7.8 cm.

See plate 48.
Inv. 1792 bis. DALLI REGOLI, 1966, n. 139.

51. *Madonna and Child*
Metalpoint (silver?), white heightening, salmon-pink prepared paper. 14.2 × 9.2 cm.

This drawing appears to have been done by the same hand as the three preceding drawings (pls. 48-50). BOTH DE TAUZIA (1881) attributed it to Lorenzo di Credi, while BERENSON (1903) held it to be an original study by Giovanni Antonio Sogliani, the Madonna being almost identical to the one appearing on another sheet by this artist, formerly in the Oppenheimer collection, in London. Instead, DEGENHART (1932) published it under the name of Giovanjacopo Castrocaro.
Provenance: E. Desperet – A. -Ch. -H. His de la Salle – Gift in 1878. Inv. RF 463. DALLI REGOLI, 1966, n. 138.

LORENZO DI CREDI, Traditional Attributions

52. *Nude Youth, standing, full-face view, holding a stick.*
Saint John the Baptist (?)
Metalpoint (silver?), white heightening, pale-pink prepared paper. 27 × 15 cm.

Formerly attributed to an anonymous fifteenth-century Florentine by A. Ch. H. His de la Salle, this drawing was given to Davide Ghirlandaio by BERENSON (1903). On the other hand, RAGGHIANTI and DALLI REGOLI (1975) ascribed it to the circle of Sandro Botticelli, Filippino Lippi and Lorenzo di Credi. On the verso, there is a study of an angel in flight, sketched in black chalk (not illustrated).
Provenance: A. Ch. H. His de la Salle – Gift in 1878. Inv. RF 434bis, r°.

53. *Head of a Youth, wearing a skull-cap*
Metalpoint (silver?), partially oxidised white heightening, beige-grey prepared paper. 21 × 20.3 cm.

This drawing, formerly attributed to Leonardo da Vinci, was related by BERENSON (1938) to a head of a youth, drawn (lower left) on a sheet attributed to Francesco Granacci and preserved in Florence (Galleria degli Uffizi, inv. 307E). DEGENHART (1932) held the sheet to be by Antonio del Ceraiolo's hand. The attribution of the drawing to Lorenzo di Credi is argued by DALLI REGOLI (1966) and, with reservations, by CORDELLIER (1985), who points out the likeness of the model's pose with that of a study, traditionally given to Raphael, that is preserved at Lille (Musée des Beaux-Arts, pl. 449). This is because of the analogy in the model's pose.
Provenance: A. Ch. H. His de la Salle – Gift in 1878. Inv. RF 462. DALLI REGOLI, 1966, n. 55.

54. *Head of a Youth, with curly hair*
Brown wash, white heightening, paper washed in ochre-yellow. 12.2 × 10.5 cm.

This drawing belongs to a group of six sheets, whose treatment is not homogeneous, that were assembled in the same mount and which bear an attribution to Lorenzo di Credi by Mariette, prior to 1775. DEGENHART (1932) attributed it to Giovanni Antonio Sogliani who, according to him, drew it in the style of Andrea del Verrocchio, the face clearly deriving from the *David* of the Museo Nazionale del Bargello in Florence.
Provenance: P. -J. Mariette – Saint-Morys – Confiscation of the property of the Émigrés in 1793, entrusted to the Museum in 1796–1797. Inv. 1784D. DALLI REGOLI, 1966, n. 62.

55. *Male Head, full-face view*
Metalpoint (silver?), grey wash, white heightening, pink prepared paper. 12.5 × 9.4 cm.

This drawing which, in the nineteenth century, was attributed to Leonardo da Vinci, was given back to Lorenzo di Credi by DEGENHART (1931).
Provenance: E. Jabach, drawing catalogued as "remainder" – Purchased for the Cabinet du Roi in 1671. Inv. 2586. DALLI REGOLI, 1966, n. 219.

56. *Head of a balding Elder, three-quarter view (right)*
Metalpoint (silver?). 16 × 14.2 cm.

MOREL D'ARLEUX (1802) attributed this drawing to Lorenzo di Credi, REISET (1866) to Leonardo da Vinci, Degenhart back to Lorenzo di Credi (manuscript note on verso of mount), or to an anonymous Lombard. It was given by BORA (1987) to a pupil of Leonardo da Vinci. According to VIATTE (2003), the closest references to the drawing should be sought in the metalpoint sheets, on prepared paper, attributed by critics to the "Lombard artists and their circle" (PEDRETTI and DALLI REGOLI, 1985) or, more precisely, to the Master of the Pala Sforzesca (Agosti, 2001).
Provenance: Cabinet du Roi. Inv. 2518.

BIBLIOGRAPHY

AGOSTI 2001

G. Agosti. *Disegni del Rinascimento in Valpadana*. Exhib. cat. Florence: Gabinetto Disegni e Stampe degli Uffizi, 2001.

AMES-LEWIS 1981

F. Ames-Lewis. *Drawing in Early Renaissance Italy*. New Haven: Yale University Press, 1981.

AMES-LEWIS 1985

F. Ames-Lewis. *Italian Renaissance Sculpture in the Time of Donatello*. Exhib. cat. Detroit: Detroit Institute of Arts, 1985.

BACOU and BEAN 1958

R. Bacou and J. Bean. *Dessins florentins de la collection de Filippo Baldinucci (1625–1696)*. Exhib. cat. Paris: Musée du Louvre, 1958.

BACOU and BEAN 1959

R. Bacou and J. Bean. *Disegni fiorentini del Museo del Louvre della collezione di Filippo Baldinucci*. Exhib. cat. Rome: Villa Farnesina alla Lungara, 1959.

BACOU, VIATTE, and SÉRULLAZ 1967

R. Bacou, F. Viatte, and M. Sérullaz. *Le Cabinet d'un grand amateur: P. J. Mariette (1694–1774)*. Exhib. cat. Paris: Musée du Louvre, Galerie Mollien, 1967.

BAMBACH 1999

C. C. Bambach. *Drawing and Painting in the Italian Renaissance Workshop: Theory and Practice 1300–1600*. Cambridge/New York: Cambridge University Press, 1999.

BAMBACH 2003

C. C. Bambach. *Leonardo da Vinci, Master Draftsman*. Exhib. cat. New York: Metropolitan Museum of Art, 2003.

BERENSON 1903

B. Berenson. *The Drawings of the Florentine Painters*, 2 vols. New York: E. P. Dutton and Company, 1903.

BERENSON 1932

B. Berenson. "Disegni inediti di Tommaso", *Rivista d'Arte*, XXIV, 1932, pp. 249-262.

BERENSON 1938

B. Berenson. *The Drawings of the Florentine Painters*. 2 vols. Chicago: The University of Chicago, 1938.

BERENSON 1961

B. Berenson. *I disegni dei pittori fiorentini*. 3 vols. Milan: Electa, 1961.

BORA 1987

G. Bora. "I leonardeschi e il ruolo del disegno". In *Disegni e dipinti leonardeschi dalle collezioni milanesi*. Exhib. cat. Milan: Palazzo Reale, 1987, pp. 11-19.

BOTH DE TAUZIA 1881

L. Both de Tauzia. *Notice des dessins de la collection His de la Salle exposés au Louvre*. Paris: Musée du Louvre, 1881.

BOTH DE TAUZIA 1888

L. Both de Tauzia. *Musée national du Louvre. Dessins, cartons, pastels et miniatures des diverses écoles, exposés, depuis 1879, dans les salles du 1er étage*. Exhib. cat. Paris: Musée du Louvre, 1888.

BOUCHOT-SAUPIQUE *et al.* 1962

J. Bouchot-Saupique *et al. Première exposition des plus beaux dessins du Louvre et de quelques pièces célèbres des collections de Paris*. Exhib. cat. Paris: Musée du Louvre, 1962.

BRIQUET 1907

C. M. Briquet. *Les filigranes. Dictionnaire historique des marques du papier*. 4 vols. Geneva: A. Jullien, 1907.

BROWN 1998

D. A. Brown. *Leonardo da Vinci. Origins of a Genius*. New Haven-London: Yale University Press, 1998.

BULE, PHIPPS DARR et al. 1992
S. Bule, A. Phipps Darr et al. *Verrocchio and Late Quattrocento Sculpture*. Symposium proceedings (Provo, Utah, April 1988; Florence; June 1989). Florence, 1992.

BUTTERFIELD 1997
A. Butterfield. *The Sculptures of Andrea del Verrocchio*. New Haven-London: Yale University Press, 1997.

CADOGAN 1983
J. K. Cadogan. "Verrocchio's Drawings Reconsidered", *Zeitschrift für Kunstgeschichte*, XLVI, no. 4, 1983, pp. 367-400.

CADOGAN 2000
J. K. Cadogan. *Domenico Ghirlandaio, Artist and Artisan*. New Haven-London: Yale University Press, 2000.

CALVI 1925
G. Calvi. *I manoscritti di Leonardo da Vinci dal punto di vista cronologico, storico e biografico*. Bologna: Zanichelli, 1925.

CAPRETTI 1996
E. Capretti. "Tipologie fiorentine di altari agli albori della Controriforma: un'indagine attraverso i disegni", in *Altari e immagini nello spazio ecclesiale*, ed. A. Forlani Tempesti. Florence: A. Pontecorboli, 1996, pp. 71-87.

CHASTEL 1950
A. Chastel. *Les dessins florentins du XVᵉ au XVIIᵉ siècle*. Paris, 1950.

CHASTEL 1955
A. Chastel. "*Carta tinta*: Les Florentins de la Renaissance tirèrent un parti admirable des fonds colorés pour leurs dessins", *L'Œil*, no. 12, December 1955, pp. 26-31.

CHENNEVIÈRES 1879
Ph. de Chennevières. "Les dessins de maîtres anciens exposés à l'École des Beaux-Arts (Part I)", *Gazette des Beaux-Arts*, XXI, second period, no. 19, 1879, pp. 505-535.

CHIAPPELLI 1925–1926
A. Chiappelli. "Il Verrocchio e Lorenzo di Credi a Pistoia", *Bollettino d'arte*, 1925–1926, I, no. 2, August 1925, pp. 49-68.

CLARK 1968
K. Clark. *The Drawings of Leonardo da Vinci in the Collection of Her Majesty the Queen at Windsor Castle*. Vol. I. London: Phaidon, 1968.

CORDELLIER 1985
D. Cordellier. "Un dessin de Raphaël au Louvre: Le Visage de la Poésie", *La Revue du Louvre et des Musées de France*, XXXV, no. 2, 1985, pp. 96-104.

DALLI REGOLI 1965
G. Dalli Regoli. "Problemi di grafica crediana", *Critica d'Arte*, no. 76, 1965, pp. 25-45.

DALLI REGOLI 1966
G. Dalli Regoli. *Lorenzo di Credi*. Milan: Edizioni di Comunità, 1966.

DALLI REGOLI 2000
G. Dalli Regoli. "Il problema dell'attribuzione nell'ambito del disegno rinascimentale: tre note su putti e Madonne", in *L'arte nella Storia. Contributi di critica e storia dell'arte per G. C. Sciolla*. Milan: Skira, 2000, pp. 341-345.

DAMISCH 1995
H. Damisch. *Traité du trait: tractatus tractus*. Exhib. cat. Paris: Musée du Louvre, Hall Napoléon, 1995.

DEGENHART 1931
B. Degenhart. "Studien über Lorenzo di Credi. I, Credi's Porträtdarstellung", *Pantheon*, VIII, September 1931, pp. 361-367.

DEGENHART 1932
B. Degenhart. "Die Schüler des Lorenzo di Credi", *Münchner Jahrbuch der Bildenden Kunst*, n. ser., IX, 1932, pp. 95-161.

EPHRUSSI 1882
C. Ephrussi. "Les dessins de la collection His de la Salle", *Gazette des Beaux-Arts*, XXIVth year, XXV, 1882, pp. 225-245.

ESCHOLIER and DEZARROIS 1935
R. Escholier and A. Dezarrois. *Exposition de l'art italien de Cimabue à Tiepolo*. Exhib. cat. Paris: Musée du Petit Palais, 1935.

FABRICZY 1897
C. Fabriczy. "Miscellanea. Studi e memorie riguardanti l'arte italiana pubblicati nell'anno 1896 nelle principali riviste di storia dell'arte in Germania", *Archivio storico dell'arte*, 2ᵈ ser., III, (review of GRONAU 1896), pp. 488-489.

GALOPPINI 1988
L. Galoppini. "Fra' Domenico: from Design to Calligraphy", *Achademia Leonardi Vinci*, I, 1988, pp. 16-20.

GOLDSCHEIDER 1959
L. Goldscheider. *Leonardo da Vinci*. London: Phaidon, 1959.

GRONAU 1896
G. Gronau. "Das sogennante Skizzenbuch des Verrocchio", *Jarbuch der Königlich Preussischen Kunstsammlungen*, XVII, pp. 65-72.

KURZ 1955
O. Kurz. "A Group of Florentine Drawings for an Altar", *Journal of the Warburg and Courtauld Institutes*, XVIII, 1955, pp. 36, 43-44.

KWAKKELSTEIN 2002

M. W. Kwakkelstein. "The Models Pose: Raphael's Early Use of Antique and Italian Art", *Artibus et Historiae*, XXIII, no. 46, 2002, pp. 37-70.

LANFRANC DE PANTHOU 1995

C. Lanfranc de Panthou. *Dessins italiens du Musée Condé à Chantilly, I: Autour de Pérugin, Filippino Lippi et Michel-Ange*. Exhib. cat. Chantilly: Musée Condé, 1995.

MEYER, SCHATBORN *et al.* 1995

B. Meyer, P. Schatborn *et al. Maestri dell'invenzione. Disegni italiani del Rijksmuseum di Amsterdam*. Exhib. cat. Florence: Istituto Universitario Olandese di Storia dell'Arte; Amsterdam: Rijksmuseum, 1995, pp. 91-92.

MÖLLER 1935

E. Möller. "Verrocchio's last Drawing", *The Burlington Magazine*, LXVI, 1935, pp. 193-195.

MONBEIG GOGUEL and BACOU 1965

C. Monbeig Goguel and R. Bacou. *Giorgio Vasari: dessinateur et collectionneur*. Exhib. cat. Paris: Musée du Louvre, 1965.

MOREL D'ARLEUX 1802

L.-M.-J. Morel d'Arleux. *Notice des dessins originaux, esquisses peintes, cartons, gouaches, pastels, èmaux, miniatures et vases Ètrusques, exposés au Musée central des Arts, dans la Galerie d'Apollon, en Messidor de l'an X de la République Française*. Part II. Exhib. cat. Paris: Musée du Louvre, 1802.

MORELLI 1893

G. Morelli. *Kunstkritische Studien über italienische Malerei die Galerie zu Berlin*. Leipzig: F. A. Brockhaus, 1890–1893.

MÜNTZ 1899

E. Müntz. *Léonard de Vinci: l'artiste, le penseur, le savant*. Paris: Hachette, 1899.

NATALI 1992

A. Natali. In *Il disegno fiorentino del tempo di Lorenzo il Magnifico*, ed. A. Petrioli Tofani. Exhib. cat. Florence: Gabinetto Disegni e Stampe degli Uffizi, 1992.

PARKER 1929

K. T. Parker. "Lorenzo di Credi (1459-1537)", *Old Master Drawings*, IV, no. 13, June 1929, p. 3.

PASSAVANT 1969

G. Passavant. *Verrocchio: Sculptures, Paintings and Drawings*, London: Phaidon, 1969.

PEDRETTI 1998

C. Pedretti. *Leonardo e la pulzella di Camaiore: inediti vinciani e capolavori delle scultura lucchese del primo Rinascimento*.

Exhib. cat. Camaiore: Museo di Arte Sacra, 1998.

PEDRETTI and DALLI REGOLI 1985

C. Pedretti and G. Dalli Regoli, *I disegni di Leonardo da Vinci e della sua cerchia nel Gabinetto Disegni e Stampe della Galleria degli Uffizi a Firenze*. Florence: Giunti, 1985.

PISANI 2001–2002

L. Pisani. *Francesco di Simone Ferrucci: indagini sull'attivà di uno scultore fiorentino tra 1460 e 1490*. Ph.D. Dissertation, University of Pisa, 2001–2002.

POPHAM and POUNCEY 1950

A. E. Popham and Ph. Pouncey. *Italian Drawings in the Department of Prints and Drawings in the British Museum. XIV–XV Centuries*. Vol. I. London: Trustees of the British Museum, 1950.

POPP 1927

A. E. Popp. "Andrea del Verrocchio", *Old Master Drawings*, no. 7, December 1927, p. 35.

POUNCEY and BACOU 1952

Ph. Pouncey and R. Bacou. *Dessins florentins du Trecento et du Quattrocento*. Exhib. cat. Paris: Musée du Louvre, 1952.

PROPECK and SÉRULLAZ 1988

L. Propeck and A. Sérullaz. *L'An V. Dessins des grands maîtres*. Exhib. cat. Paris: Musée du Louvre, 1988.

RAGGHIANTI 1967

C. L. Ragghianti, "Note ai disegni di Francesco di Giorgio", *Critica d'arte*, XIV, no. 89, 1967, pp. 38-53.

RAGGHIANTI COLLOBI 1974

L. Ragghianti Collobi. *Il libro di disegni del Vasari*. Florence: Vallecchi, 1974.

RAGGHIANTI and DALLI REGOLI 1975

C. L. Ragghianti and G. Dalli Regoli. *Firenze 1470–1480. Disegni dal modello*. Pisa: University of Pisa, 1975.

RAVAISSON-MOLLIEN 1888

Ch. Ravaisson-Mollien. "Pages autographes et apocryphes de Léonard de Vinci". Excerpt from *Mémoires de la Société nationale des Antiquaires de France*, XLVIII, 1888, pp. 1-16.

REISET 1866

F. Reiset. *Notice des dessins, cartons, pastels, miniatures et émaux, exposés dans les salles du Ier étage au Musée impérial du Louvre. Première partie: Écoles d'Italie, Écoles Allemande, Flamande et Hollandaise*. Paris: Musée du Louvre, 1866.

ROUCHÈS 1931

G. Rouchès. *Exposition de dessins italiens, XIVᵉ, XVᵉ et XVIᵉ siècles*, Exhib. cat. Paris: Musée national de l'Orangerie des Tuileries, 1931.

Sérullaz, Bacou *et al.* 1965
> M. Sérullaz, R. Bacou *et al. Le xvi^e Siècle Européen, Dessins du Musée du Louvre.* Exhib. cat. Paris: Musée du Louvre, 1965.

Suida 1929
> W. Suida. *Leonardo und sein Kreis.* Munich: F. Brockmann, 1929.

Valentiner 1932
> W. R. Valentiner. "Leonardo and Desiderio", *The Burlington Magazine*, lxi, no. 353, August 1932, pp. 53-59.

Vasari 1568
> G. Vasari. *Le Vite de' più eccellenti Pittori, Scultori ed Architettori.* Florence: G. Milanesi, ed., 1906, vol. iii, pp. 357-377 (Andrea del Verrocchio); vol. iv, pp. 563-571 (Lorenzo di Credi).

Vergnet-Ruiz and Jamot 1935
> J. Vergnet-Ruiz and P. Jamot. *Portraits et figures de femmes: pastels et dessins.* Exhib. cat. Paris: Musée national de l'Orangerie des Tuileries, 1935.

Vertova 1976
> L. Vertova. "Maestri Toscani del Quattro e del Primo Cinquecento", in *Biblioteca di disegni*, vol. xix, Florence, 1976.

Viatte *et al.* 1989
> F. Viatte *et al. Léonard de Vinci, les études de draperie.* Exhib. cat. Paris: Musée du Louvre, Hall Napoléon, 1989.

Viatte 1994
> F. Viatte. "Verrocchio et Leonardo da Vinci : à propos des 'têtes idéales'". In *Florentine Drawing at the Time of Lorenzo the Magnificent.* Symposium proceedings (Florence, Villa Spelman, 1992), Bologna: Nuova Alfa Editoriale, 1994, pp. 45-57.

Viatte 2003
> F. Viatte. In *Léonard de Vinci, dessins et manuscrits.* Exhib. cat. Paris: Musée du Louvre, Hall Napoléon, 2003 (forthcoming).

Wright and Rubin 1999
> A. Wright and P. Rubin. In *Renaissance Florence: The Art of the 1470s.* Exhib. cat. London: National Gallery, 1999.

Photographic Credits

Erich Lessing: 4, 7–10, 12–27, 30, 32–55; Dominique Cordellier: no. 11;
RMN/Michèle Bellot: cover, no. 1, 5, 6, 28, 29, 56;RMN/R. G. Ojeda: no. 2, 3; RMN/J. G. Berizzi: no. 31

Paper
This book is printed on Satimat naturel 170 g;
cover: ArjoWiggins Impressions Keaykolour Nature Schiste 250 g

Colour Separation
Galasele, Milan

Printed April 2003
by Leva Arti Grafiche, Sesto San Giovanni, Milan, Italy,
for the Musée du Louvre, Paris, and for 5 Continents Editions, Milan